The
Complete Book of
Coloring
for Grown Ups

The Complete Book of Coloring for Grown Ups

ARCTURUS

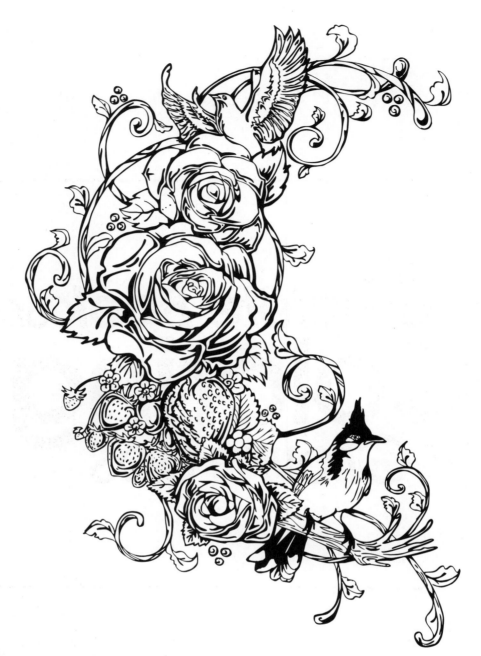

ARCTURUS

This edition published in 2016 by Arcturus Publishing Limited
26/27 Bickels Yard, 151–153 Bermondsey Street,
London SE1 3HA

Copyright © Arcturus Holdings Limited

ISBN: 978-1-78599-018-2
AD004805NT
Supplier 29, Date 0516, Print Run 5402

Printed in China

Introduction

Beneficial in so many ways, coloring calms the mind, occupies
the hands and is a pleasurable way to relax and unwind.
Contrary to popular belief, it unlocks creativity and helps you
enter a freer state of being.

 The Complete Book of Coloring for Grown Ups is packed with
wonderful designs from the worlds of nature and art,
all ready for you to color in. By taking part in
this gentle activity, not only will you de-
stress your mind and body, you will
also produce your own beautiful
artwork to treasure.

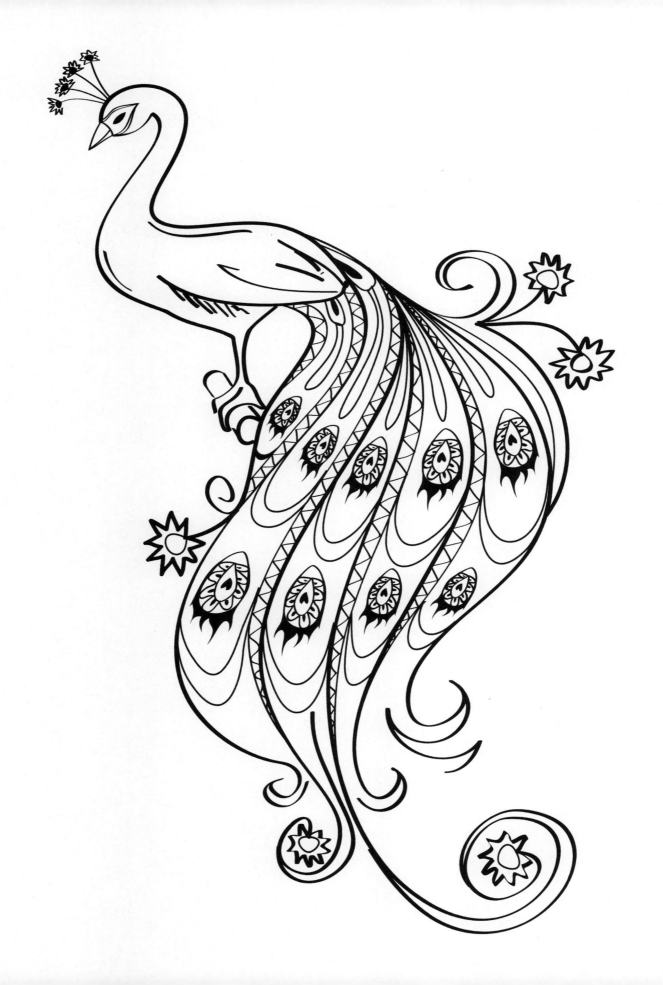

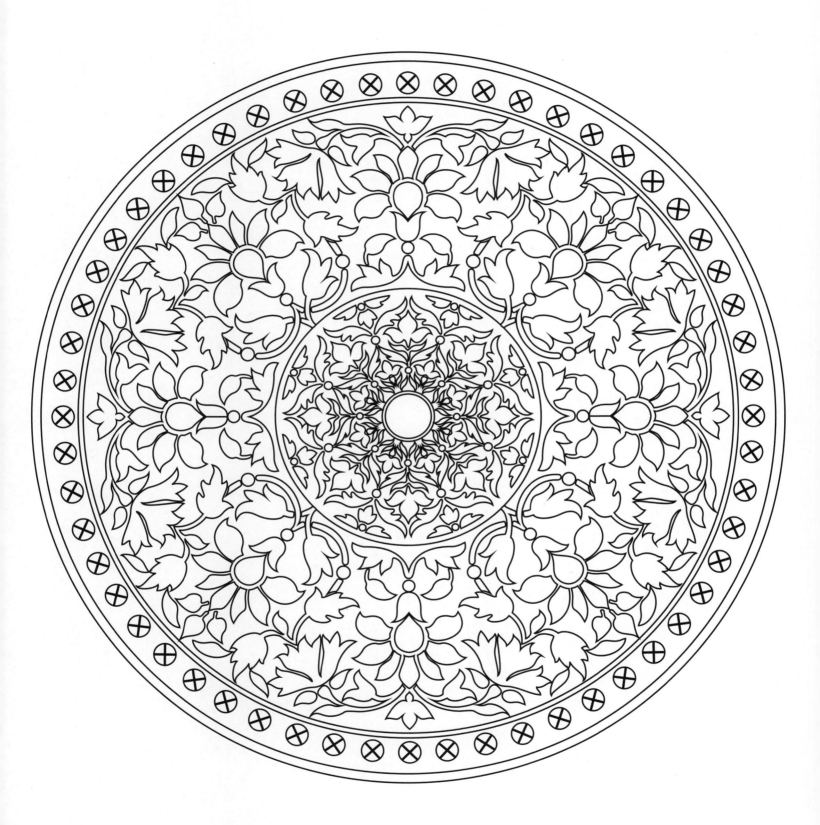

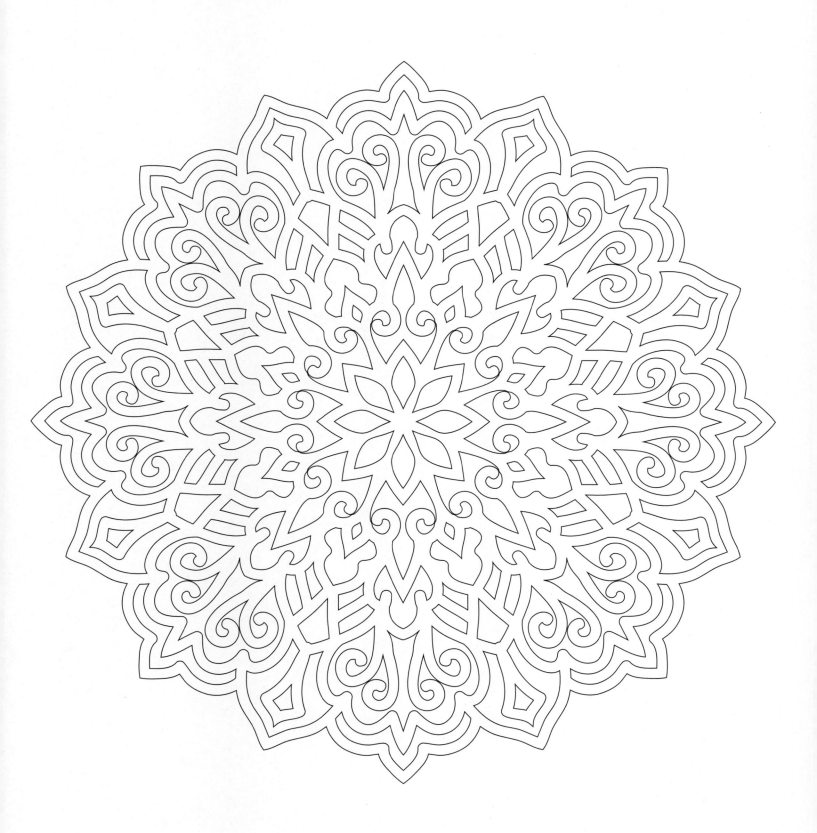

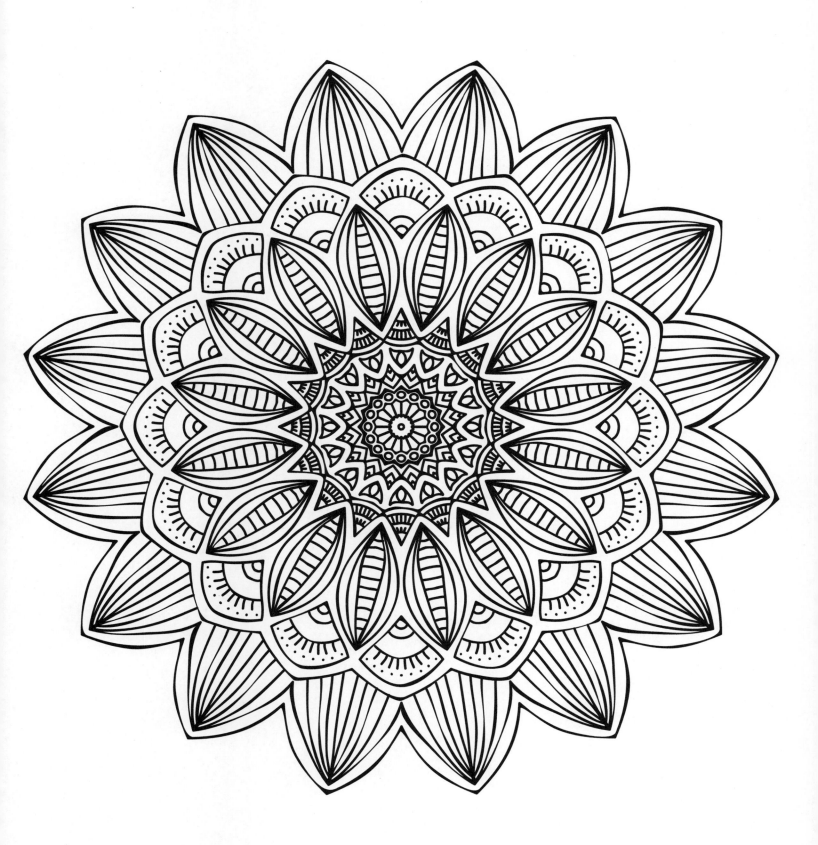

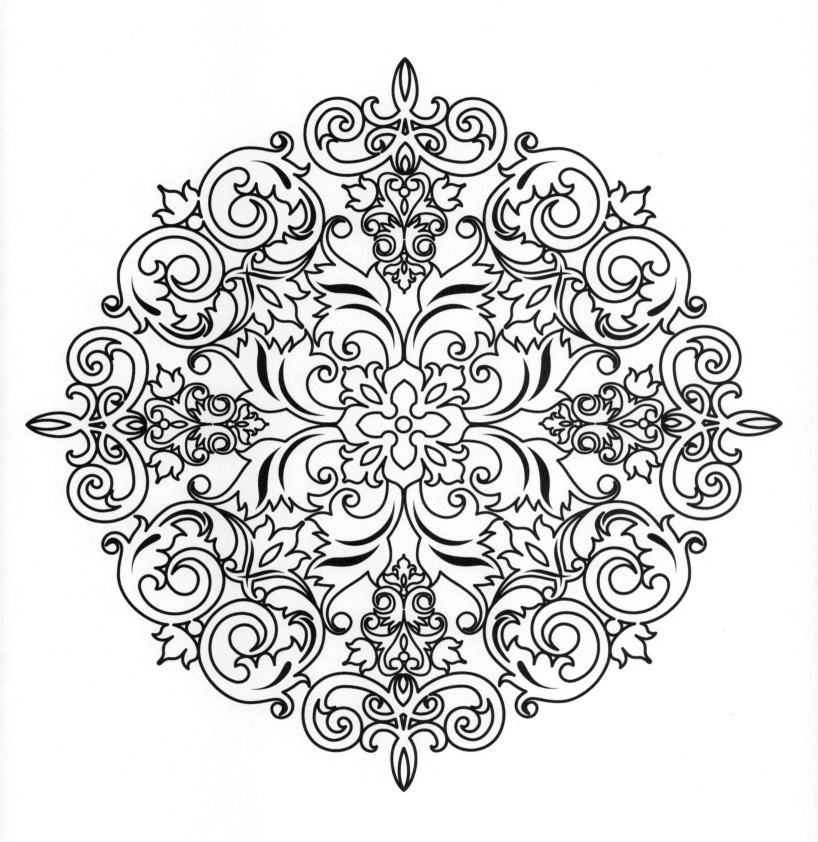

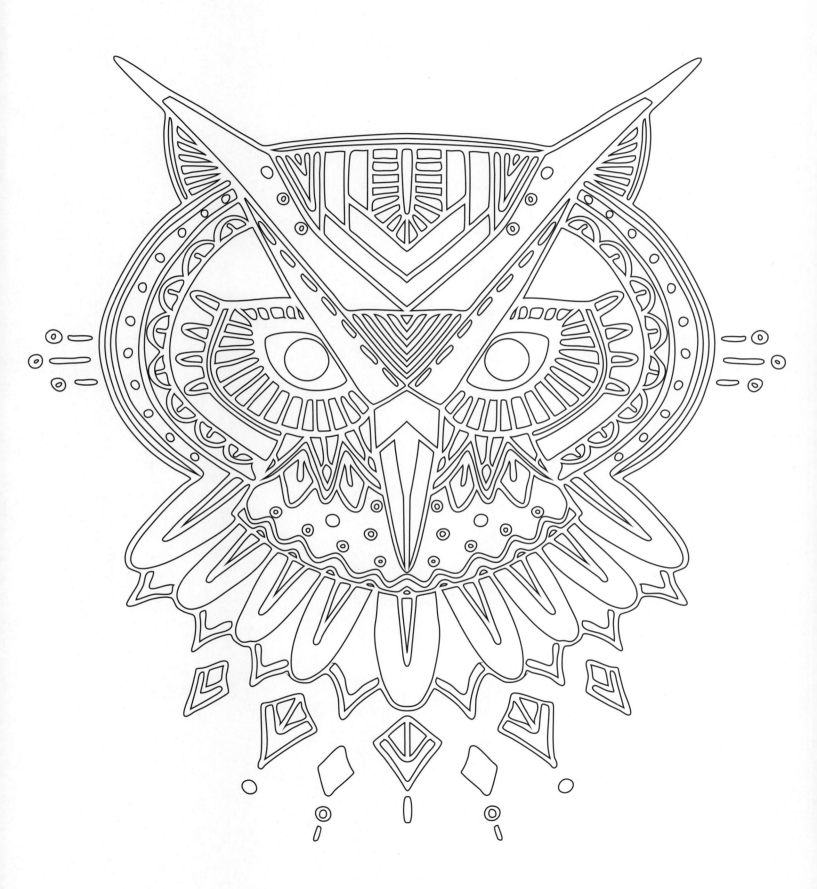

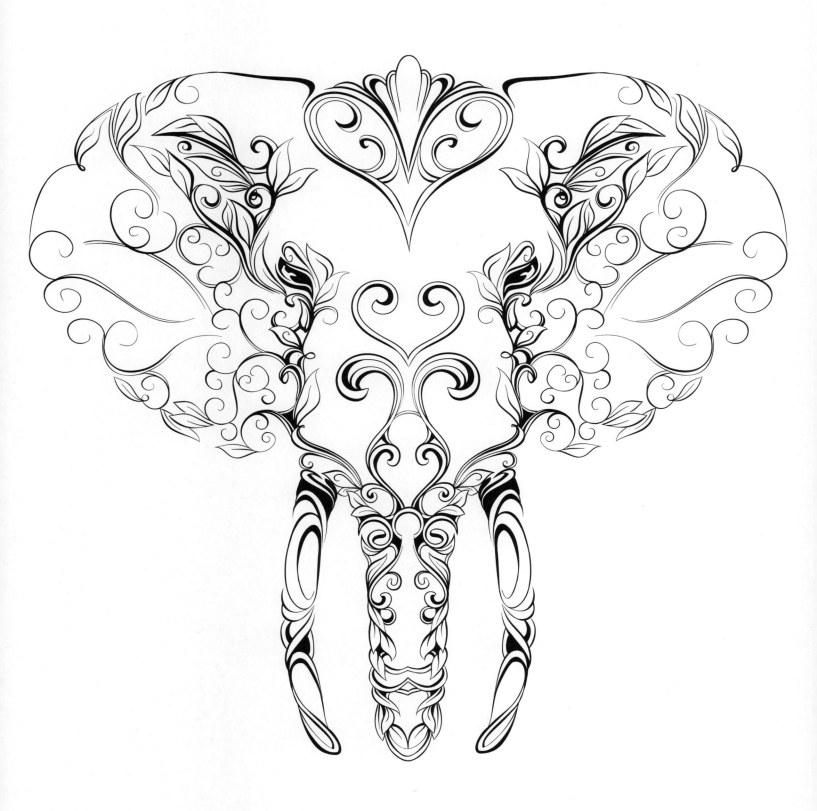

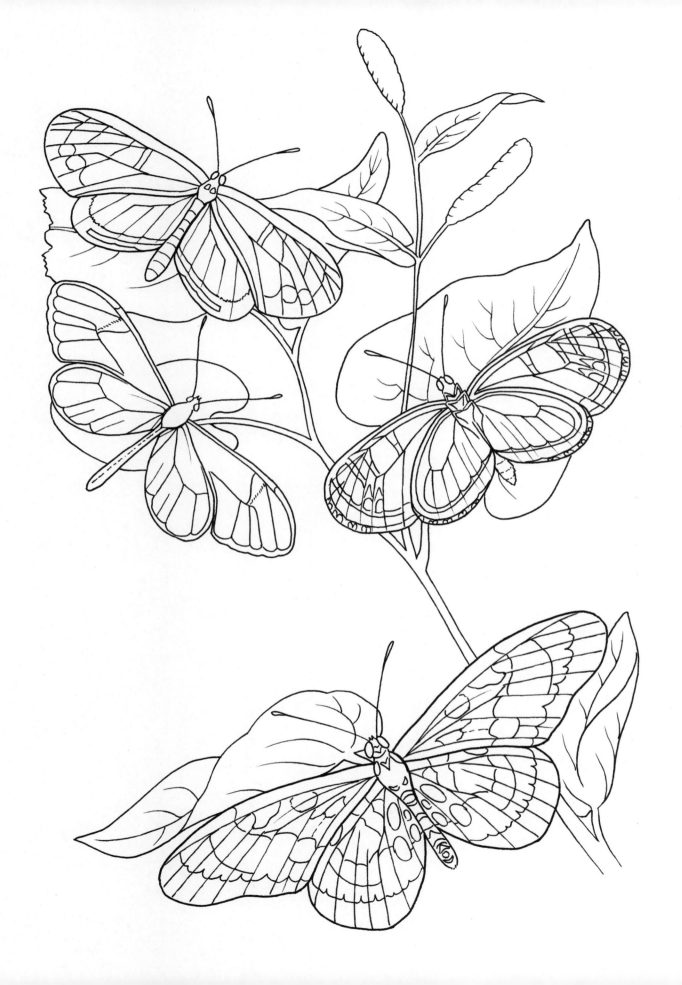

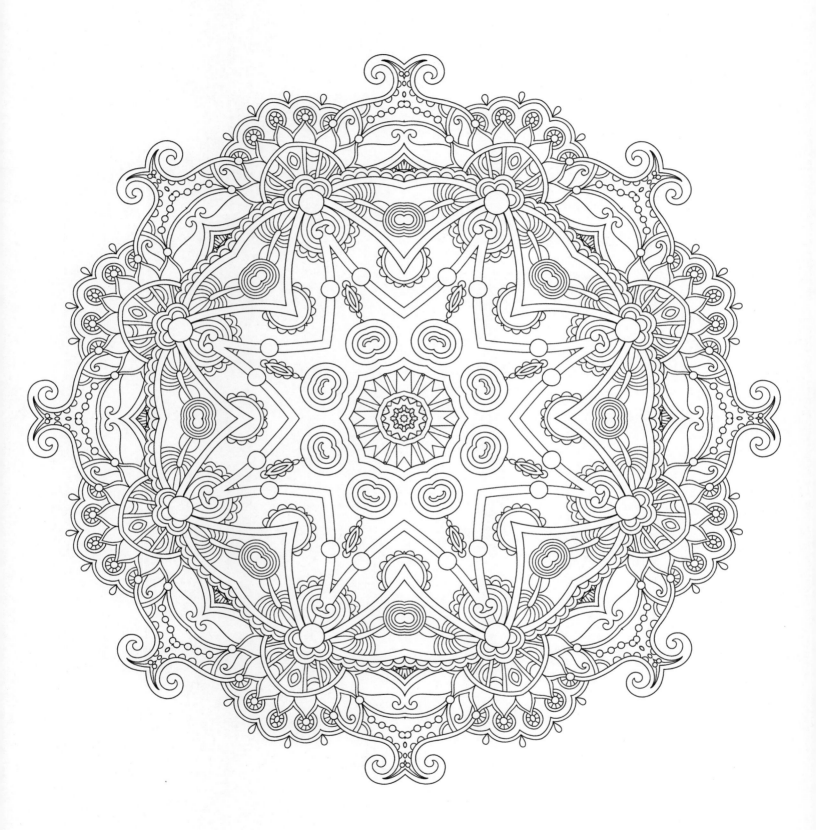

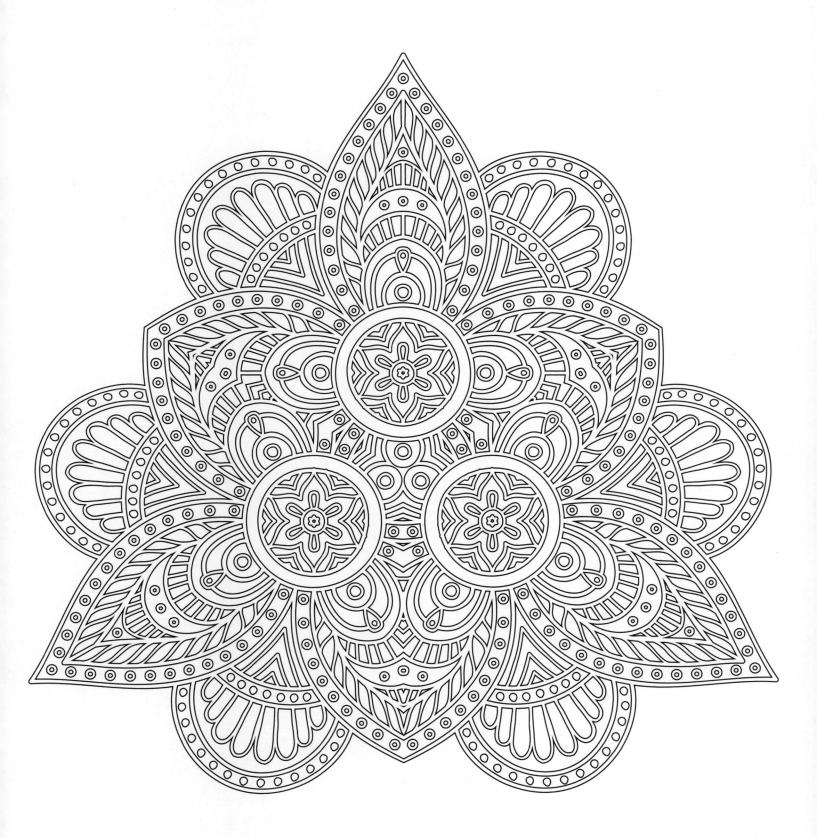

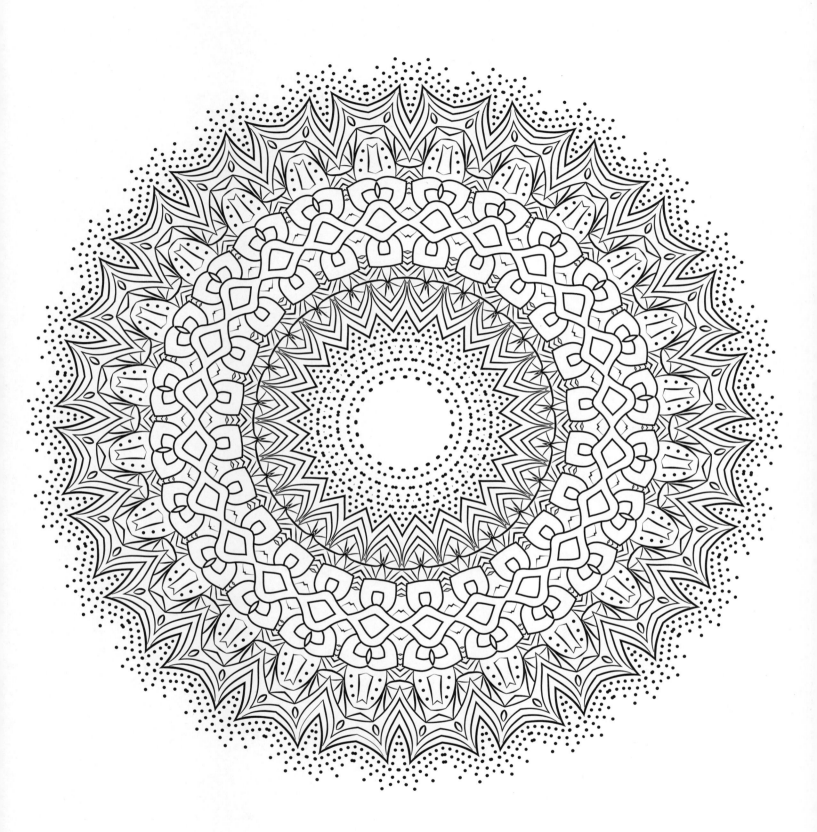

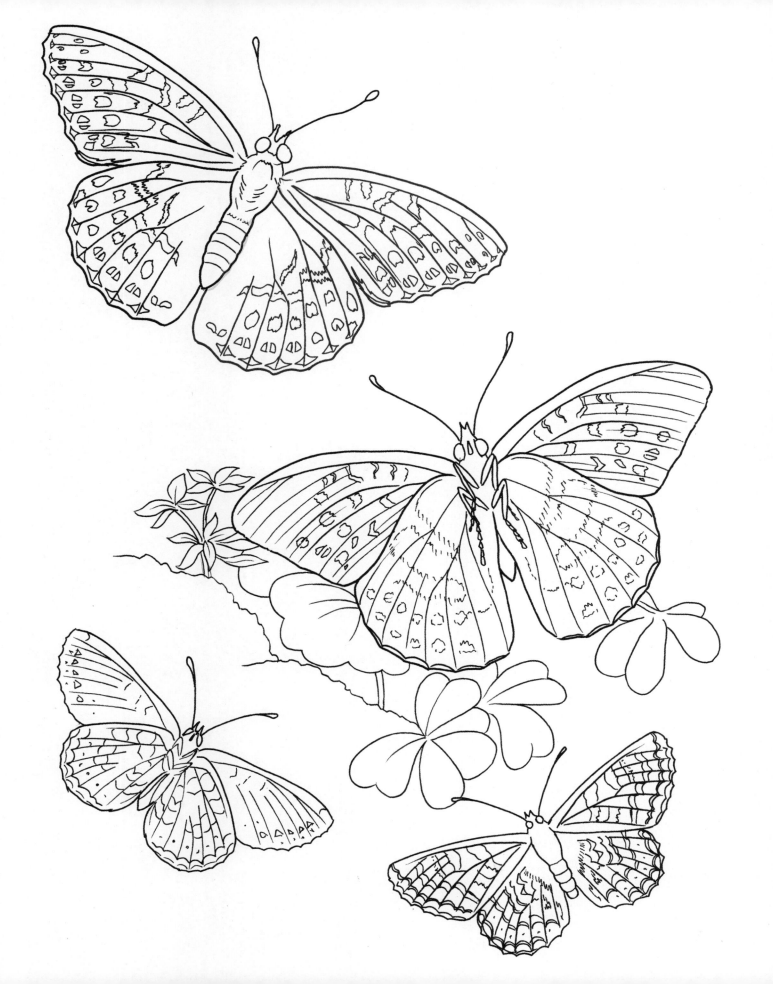

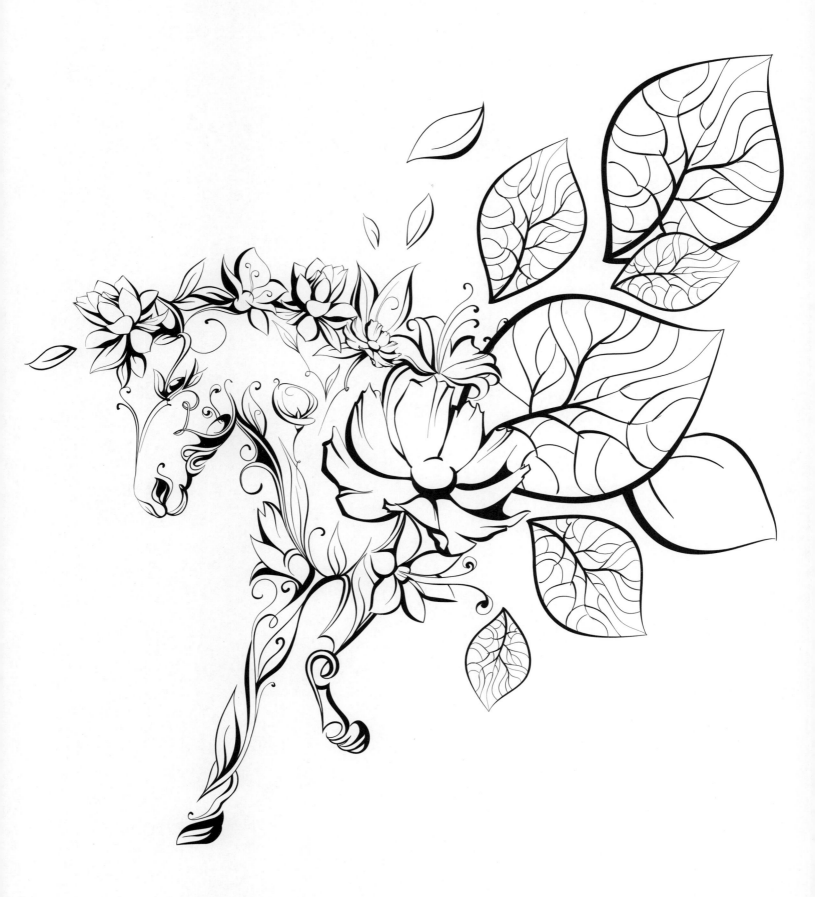

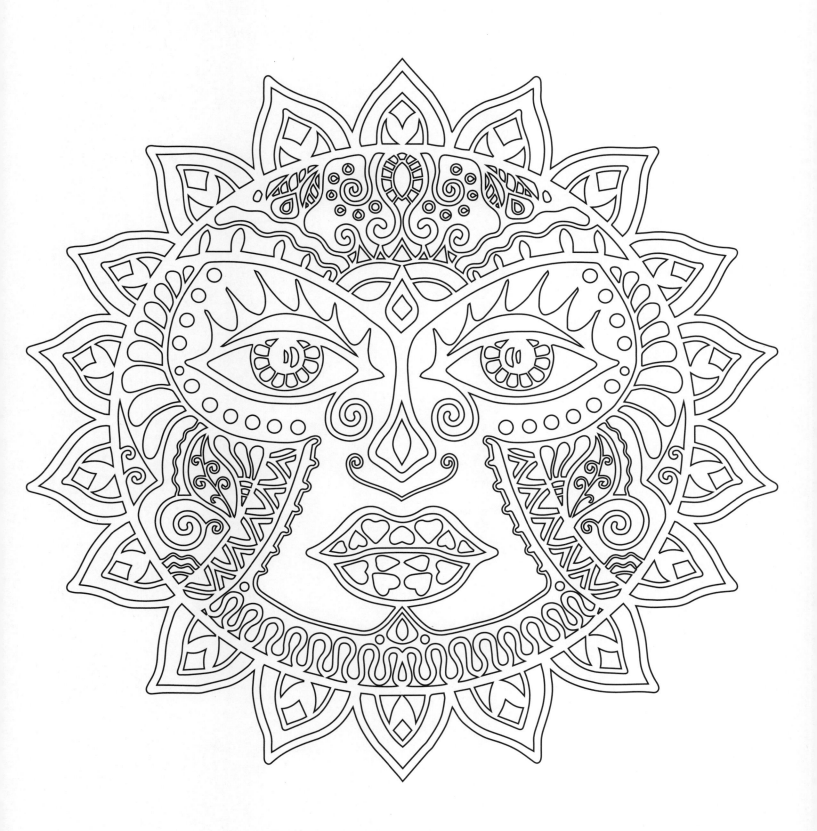

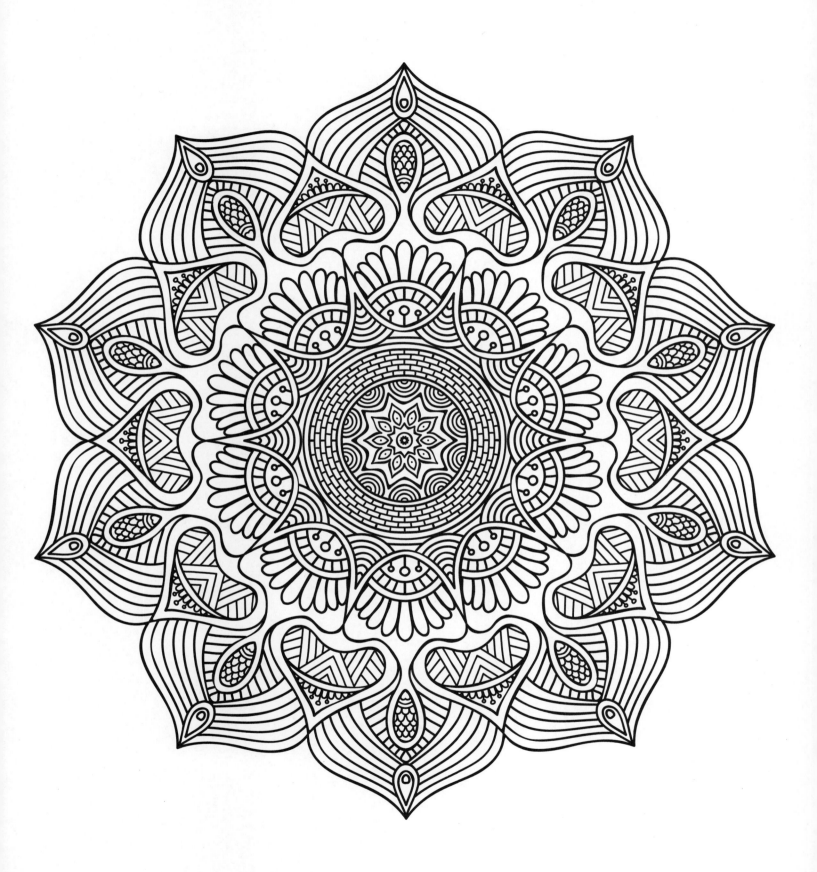

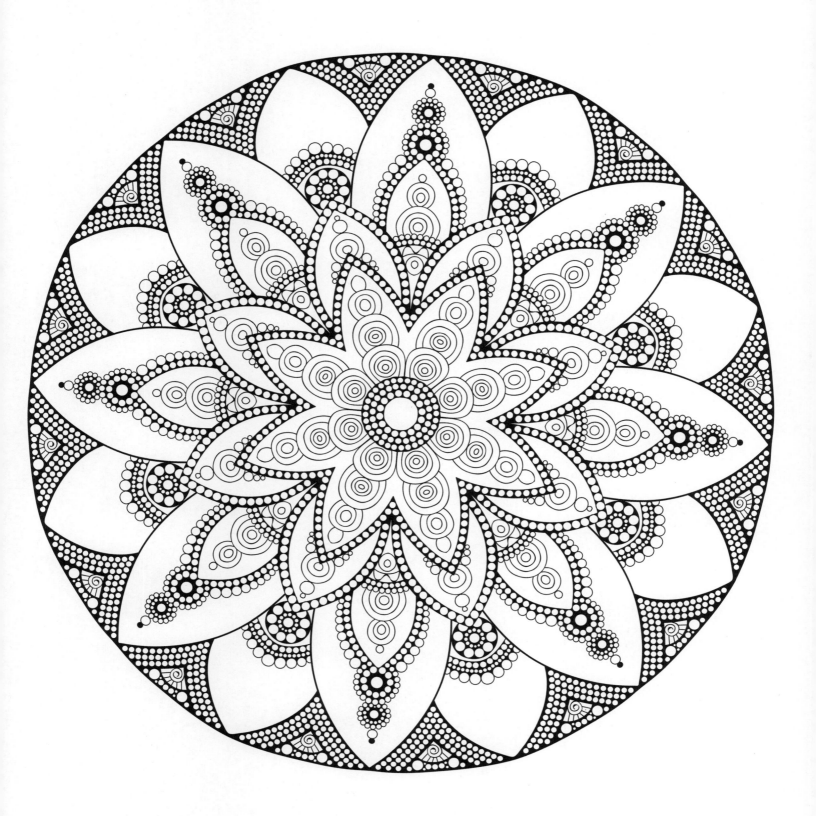

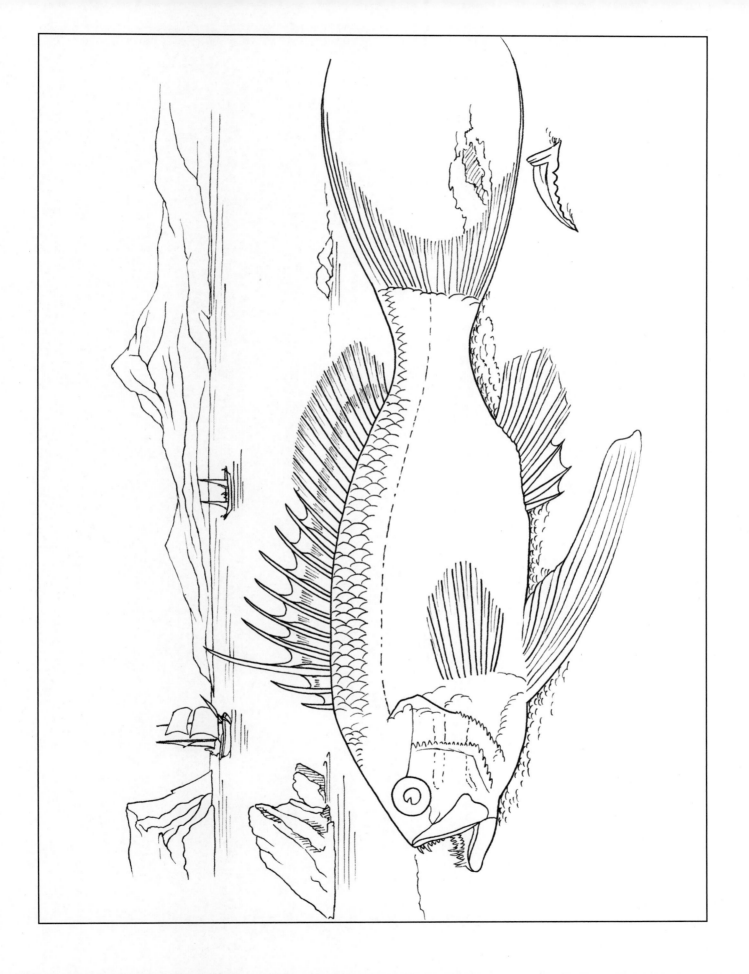

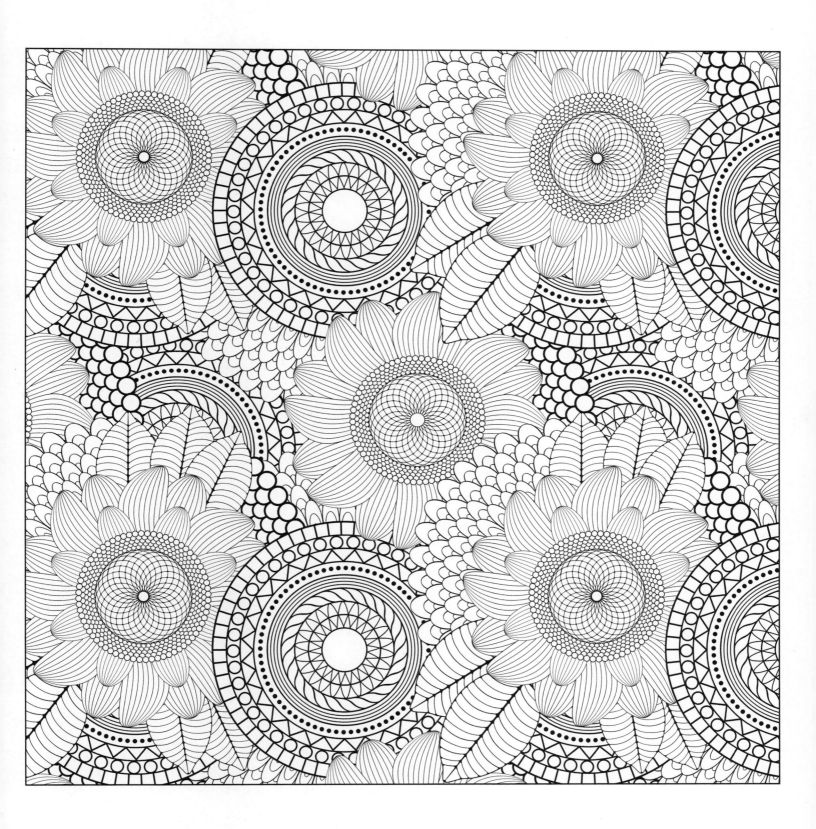

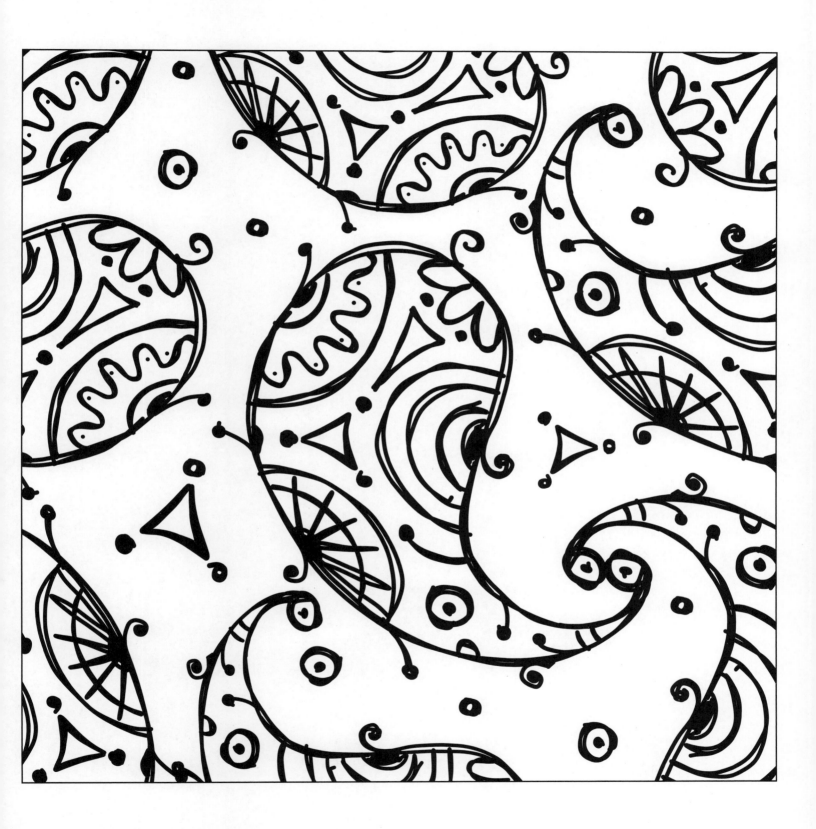

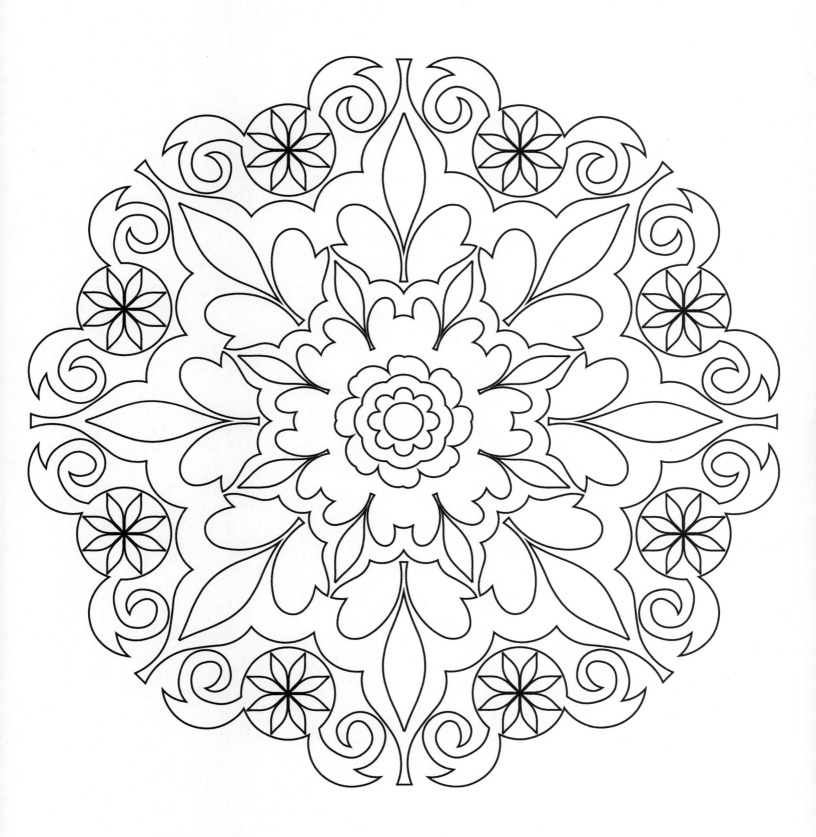

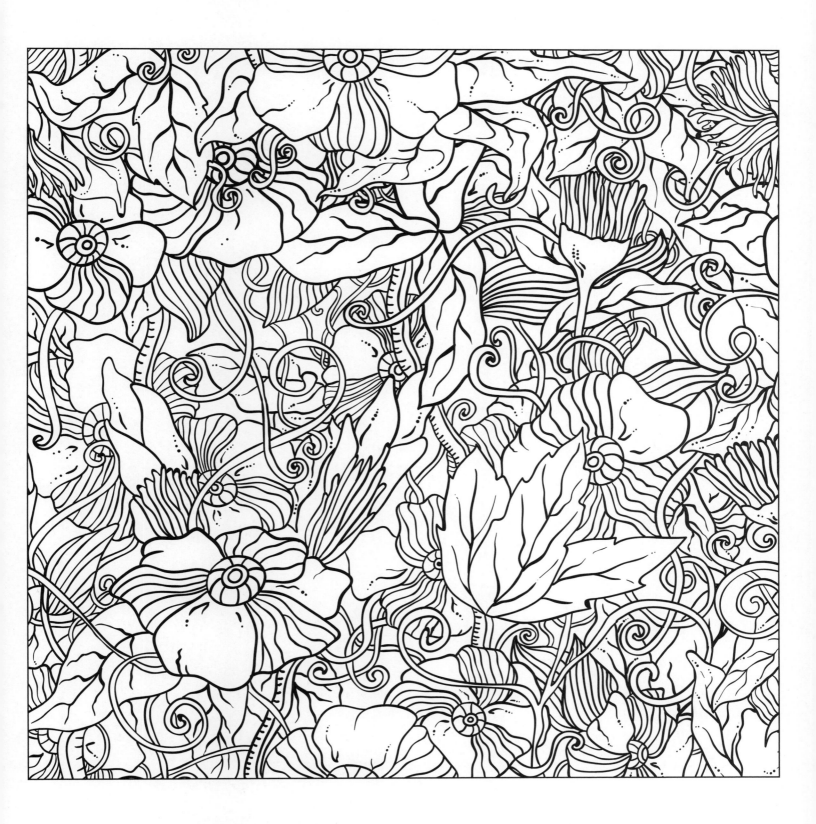

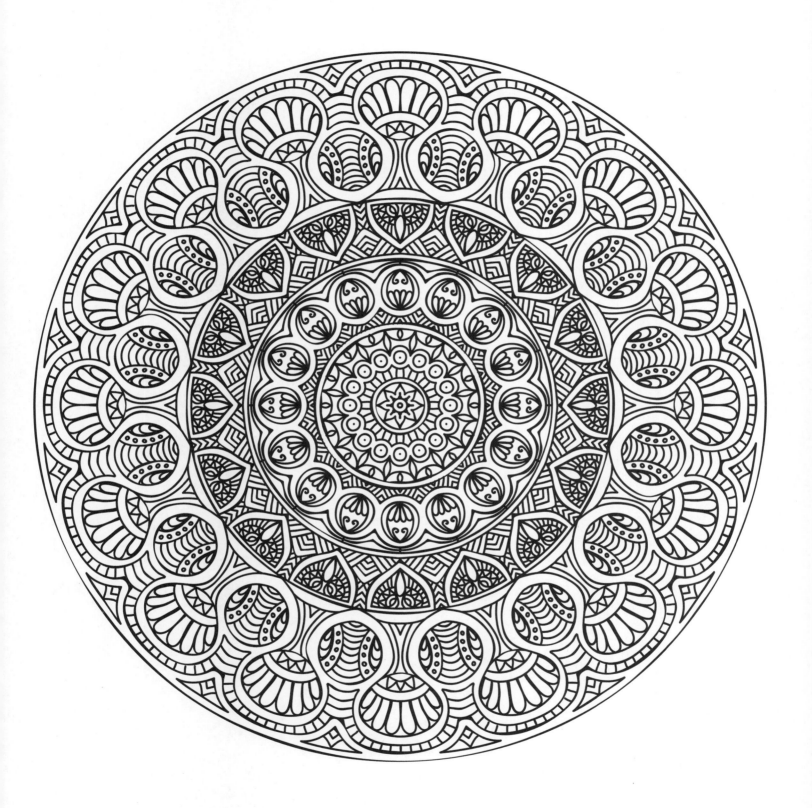

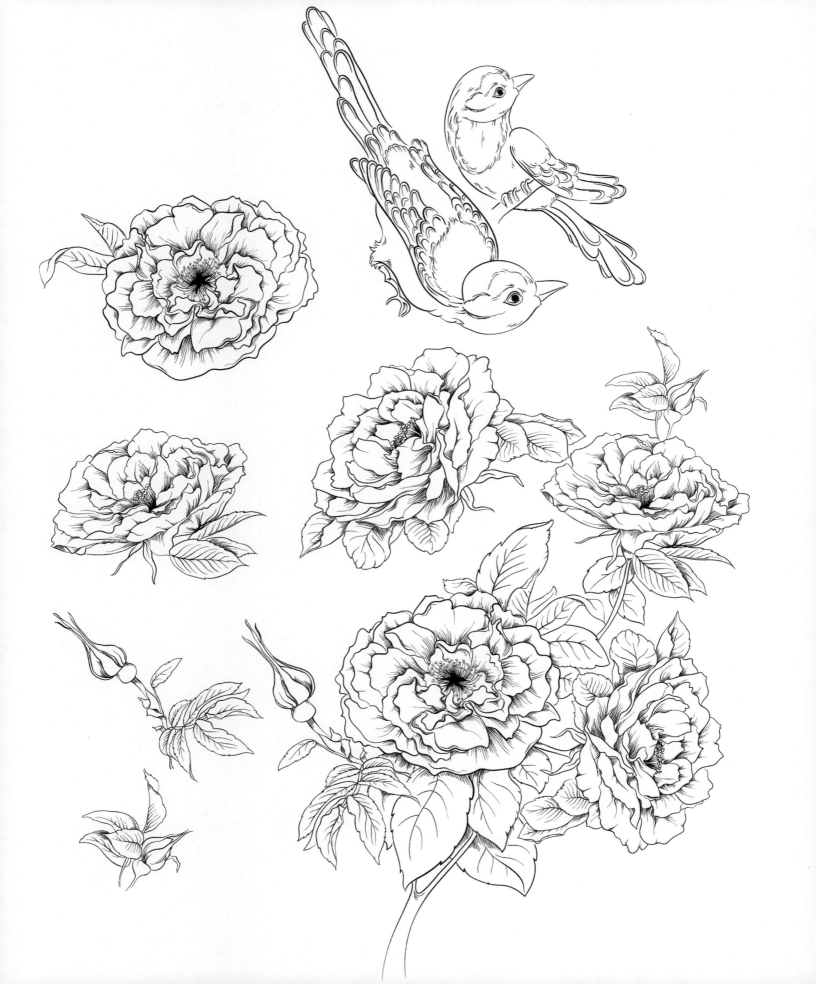

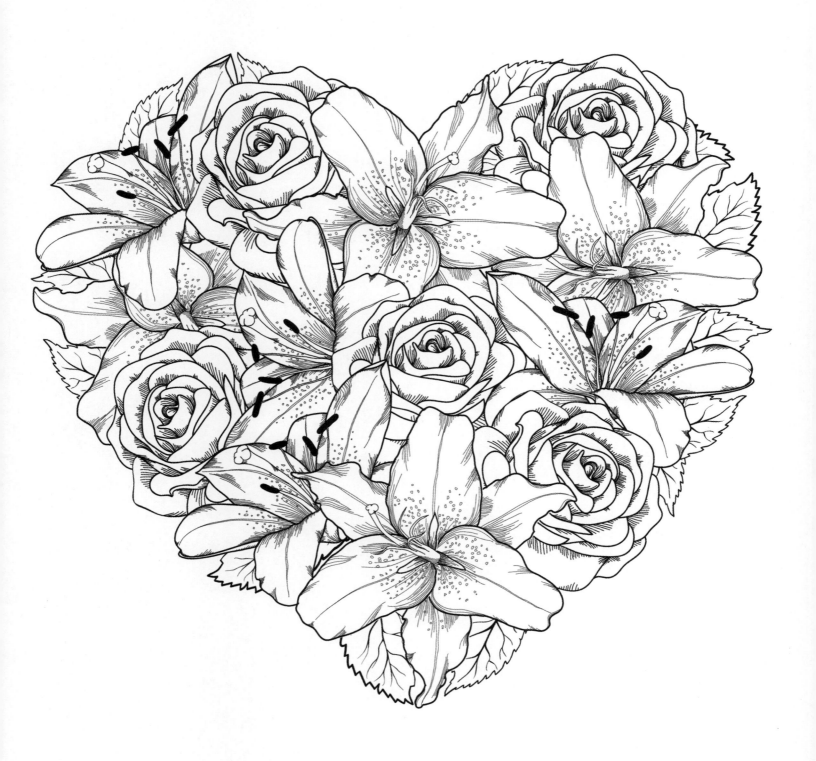

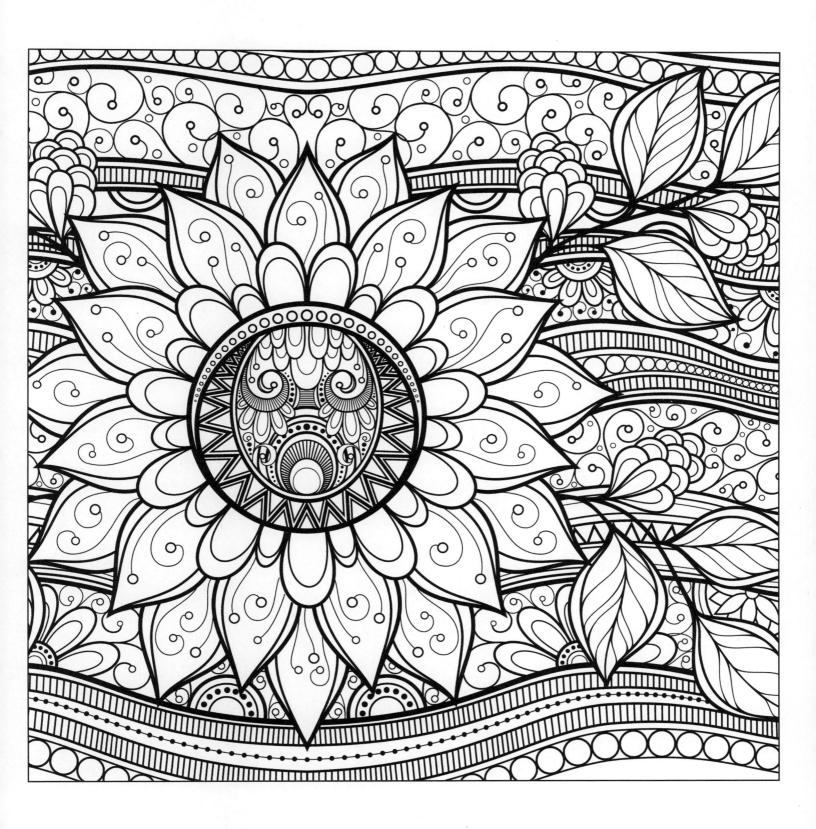

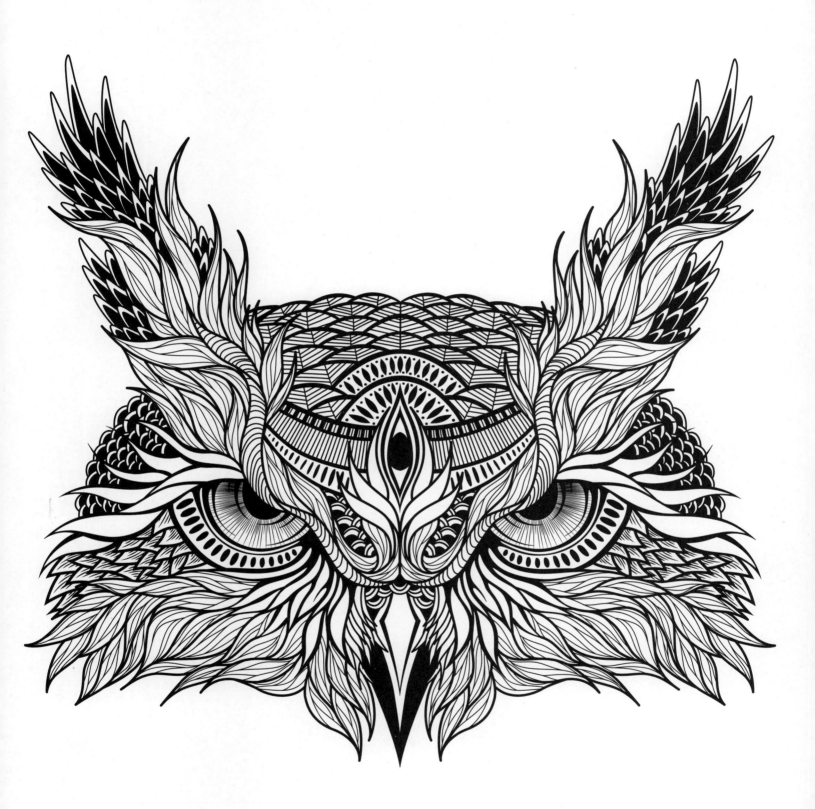

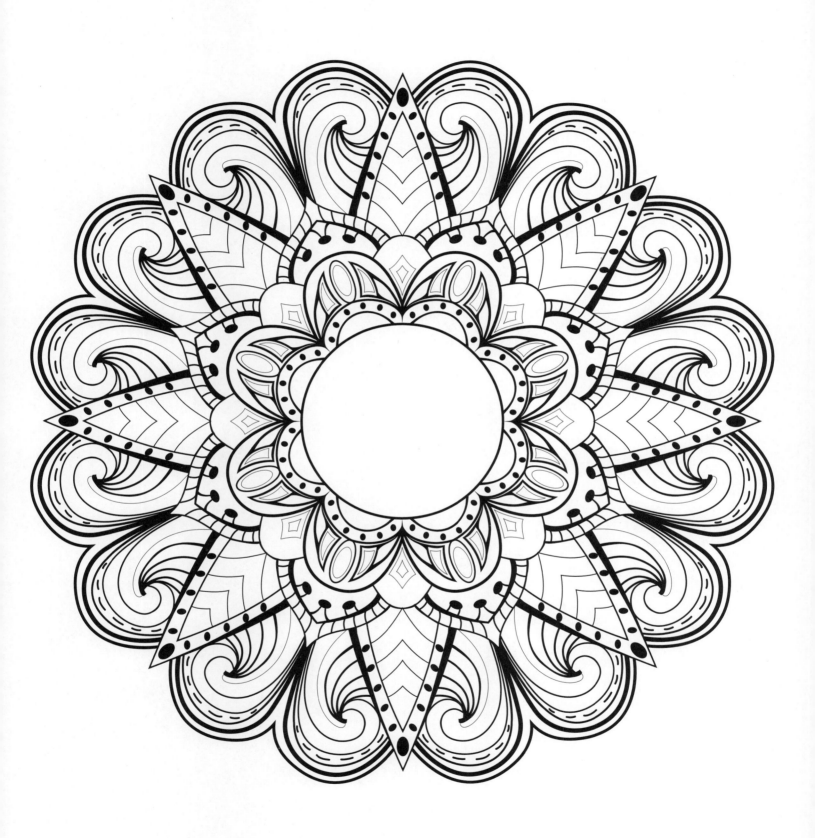

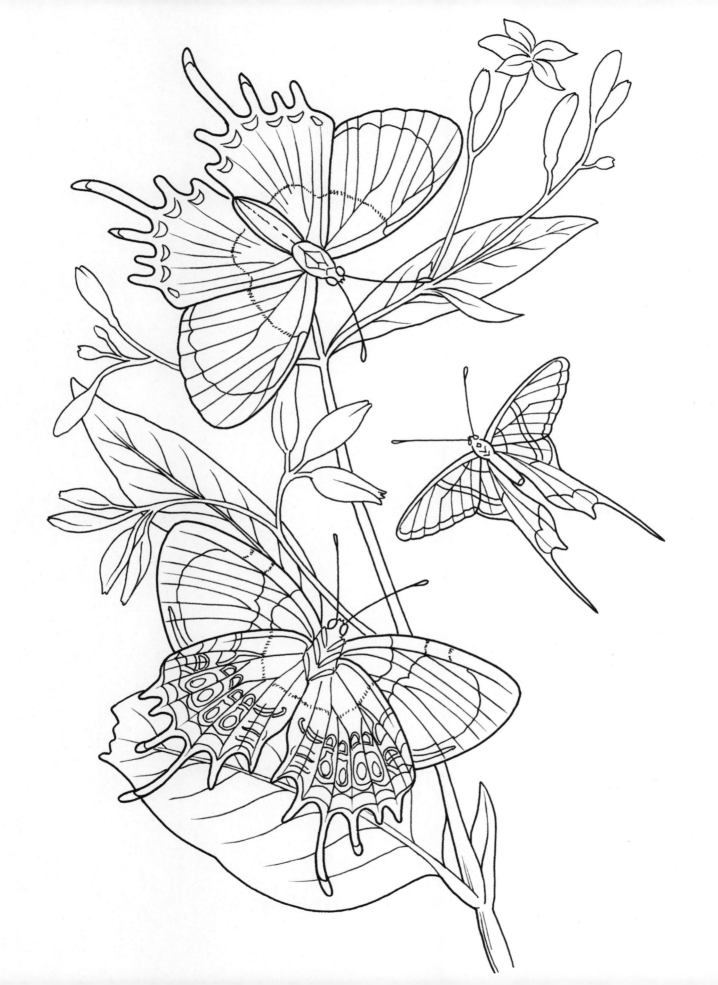

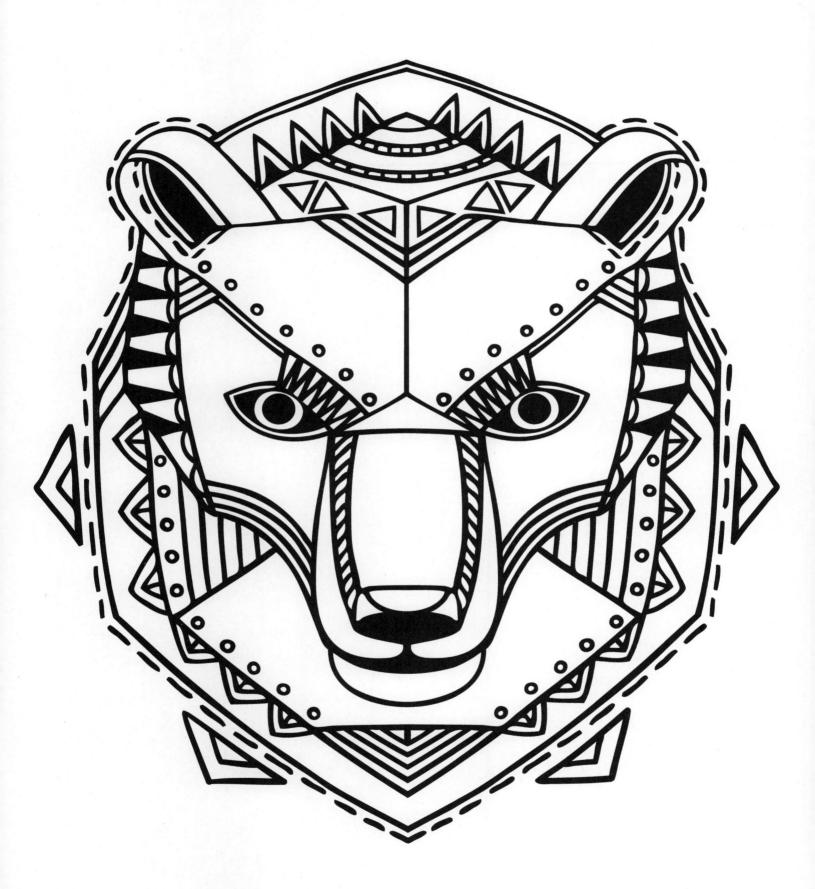

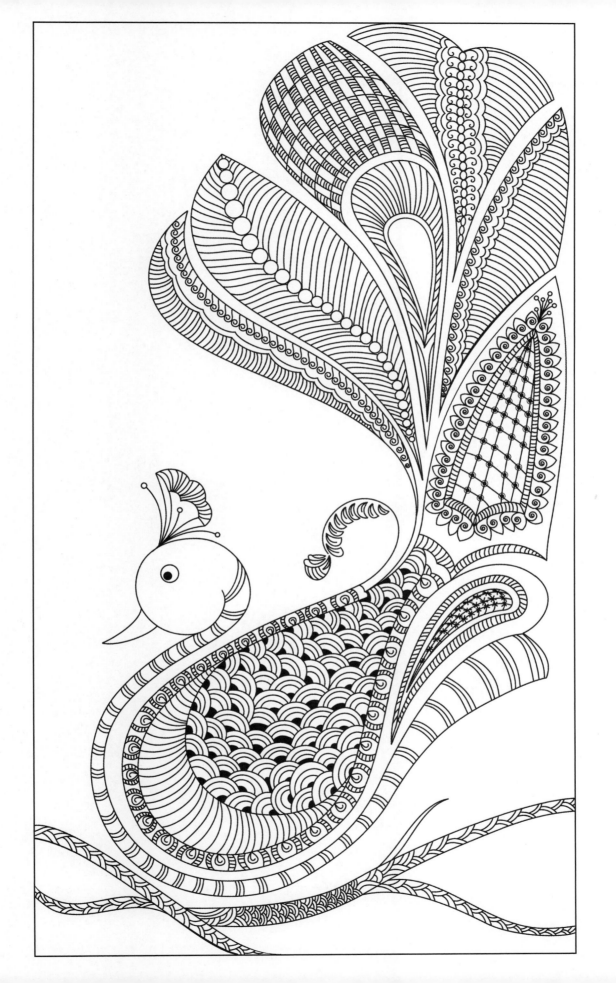

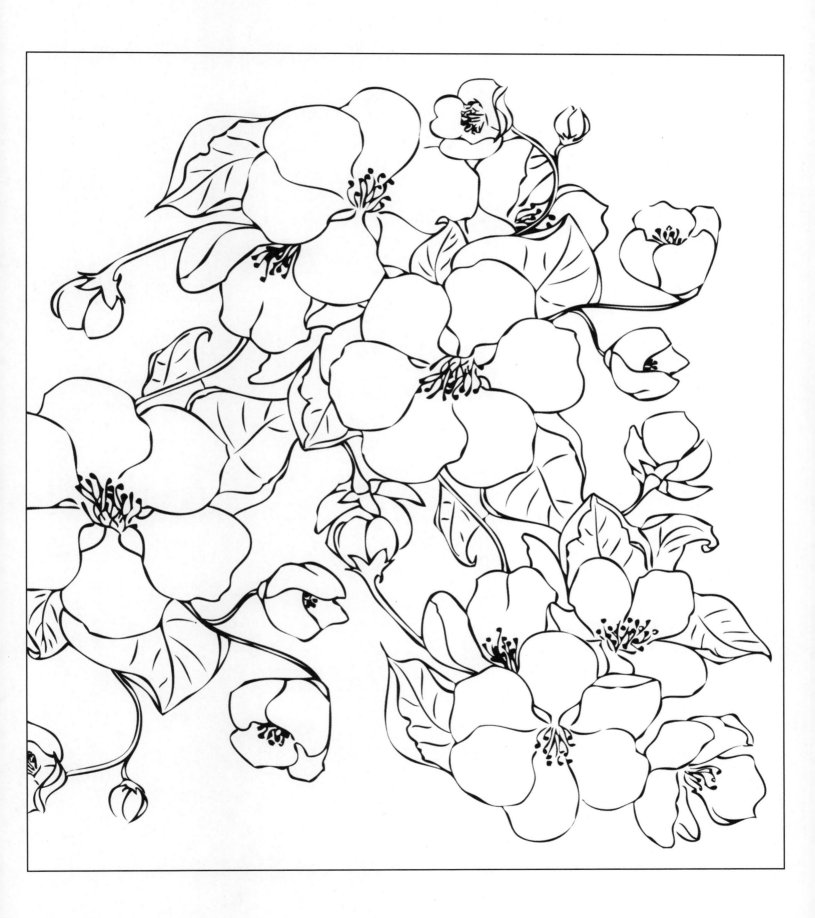

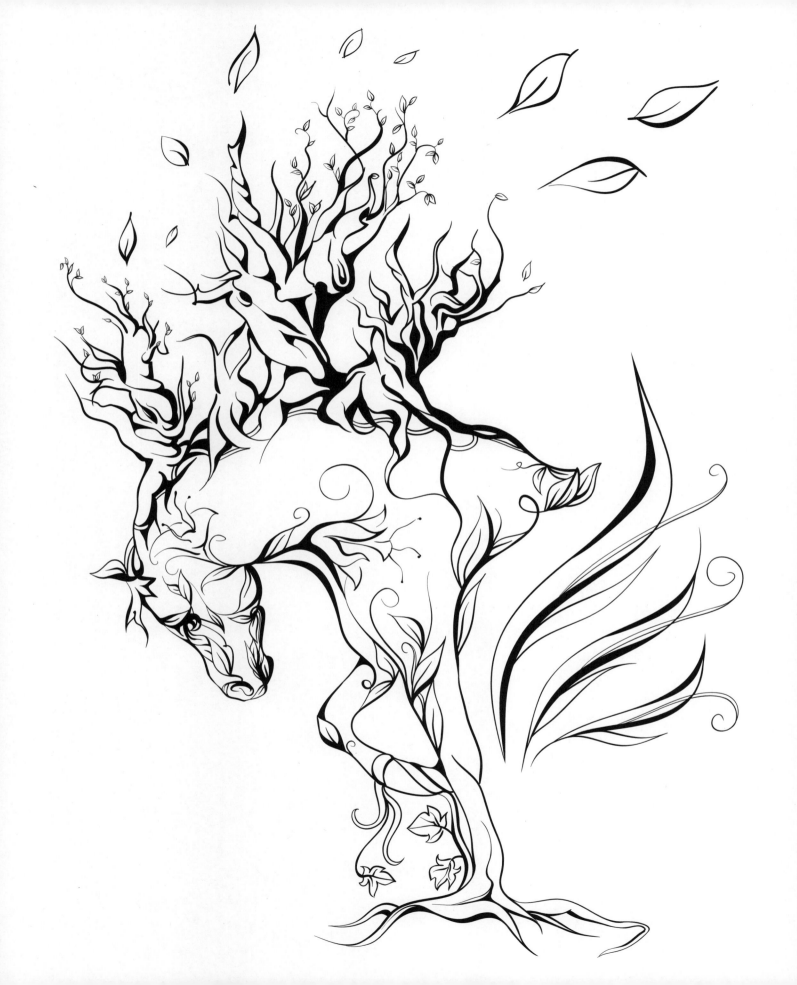

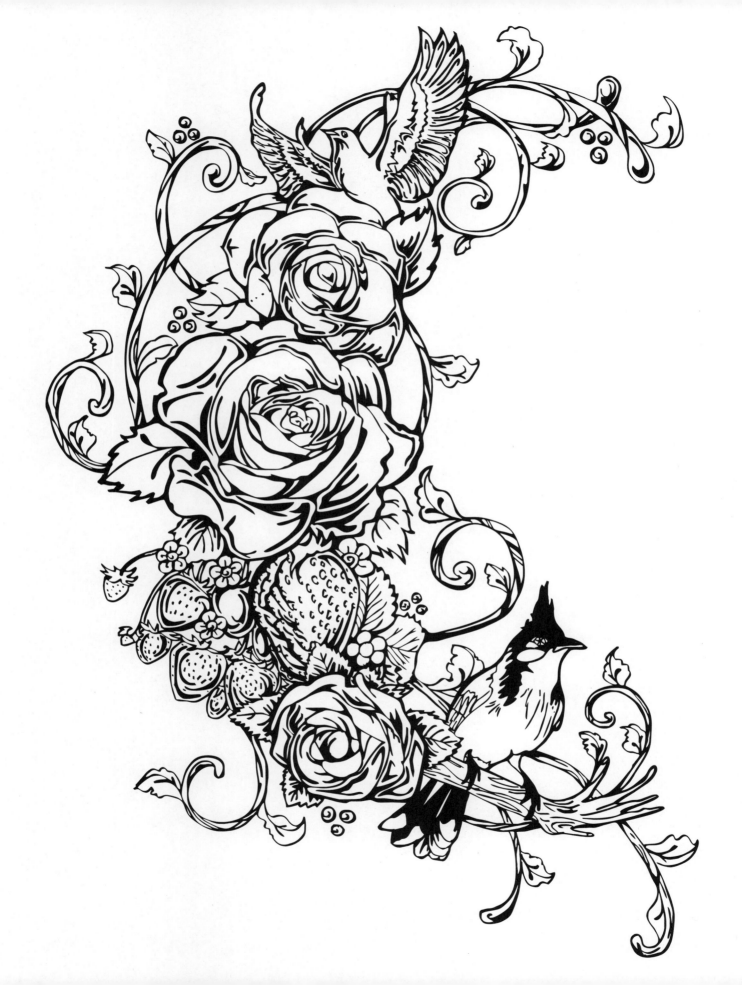

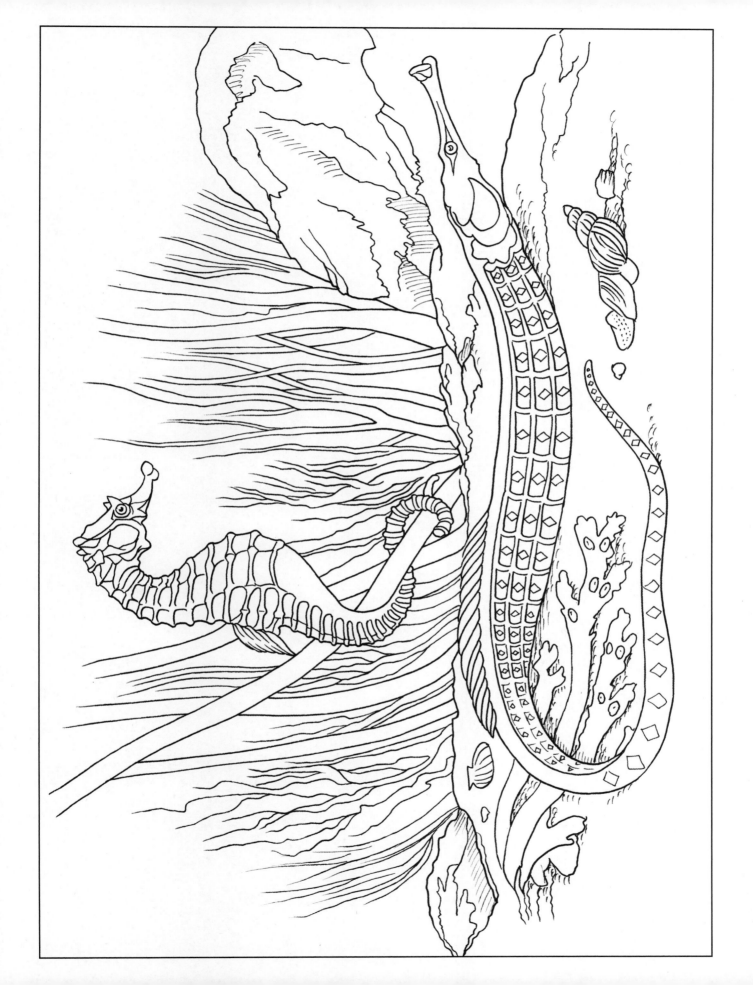

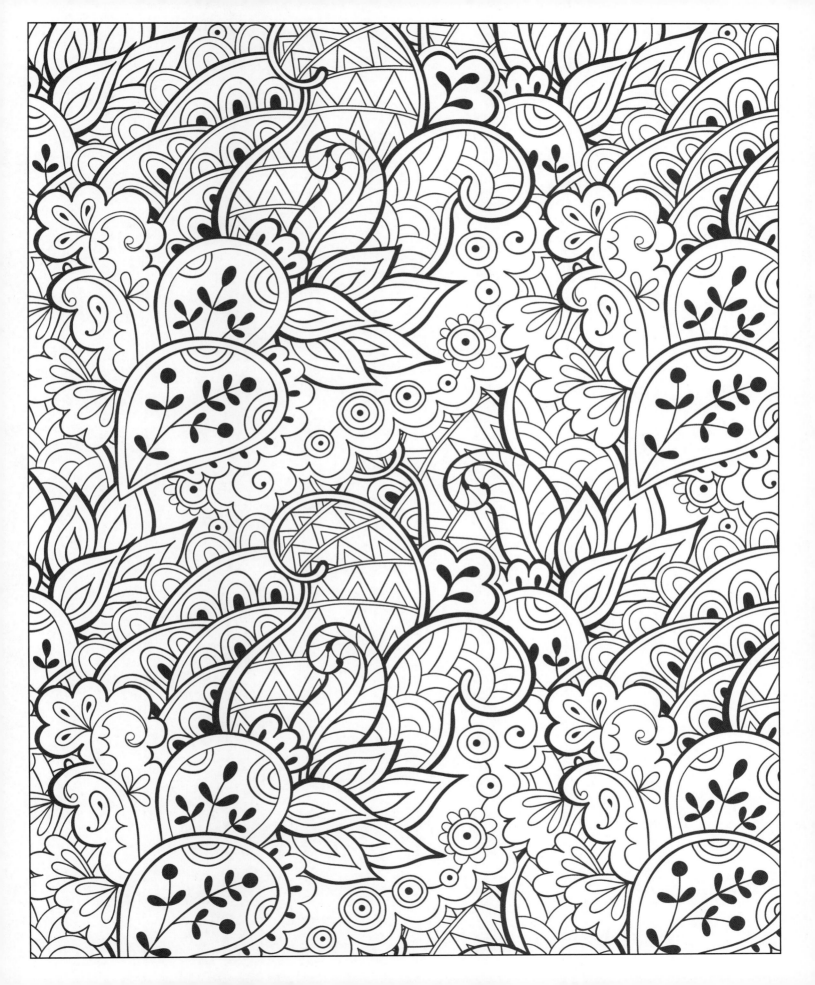

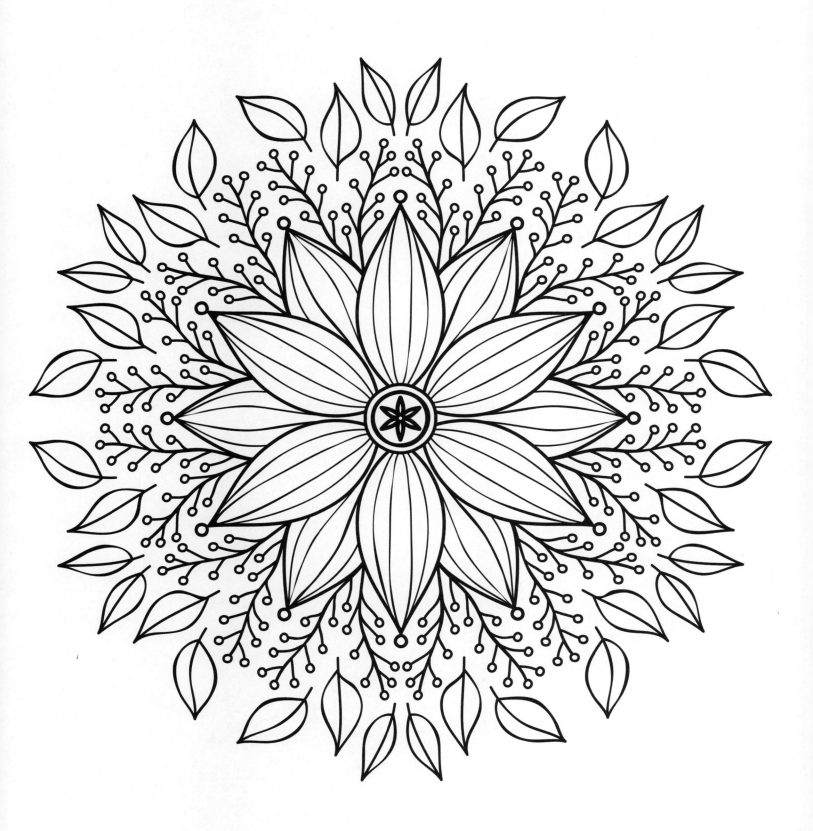

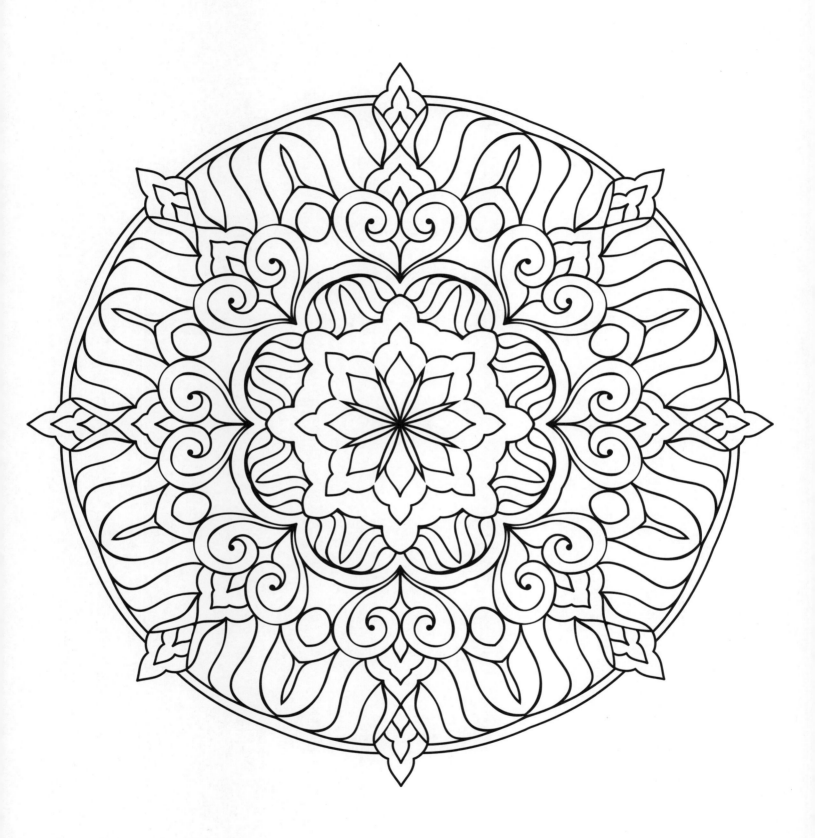

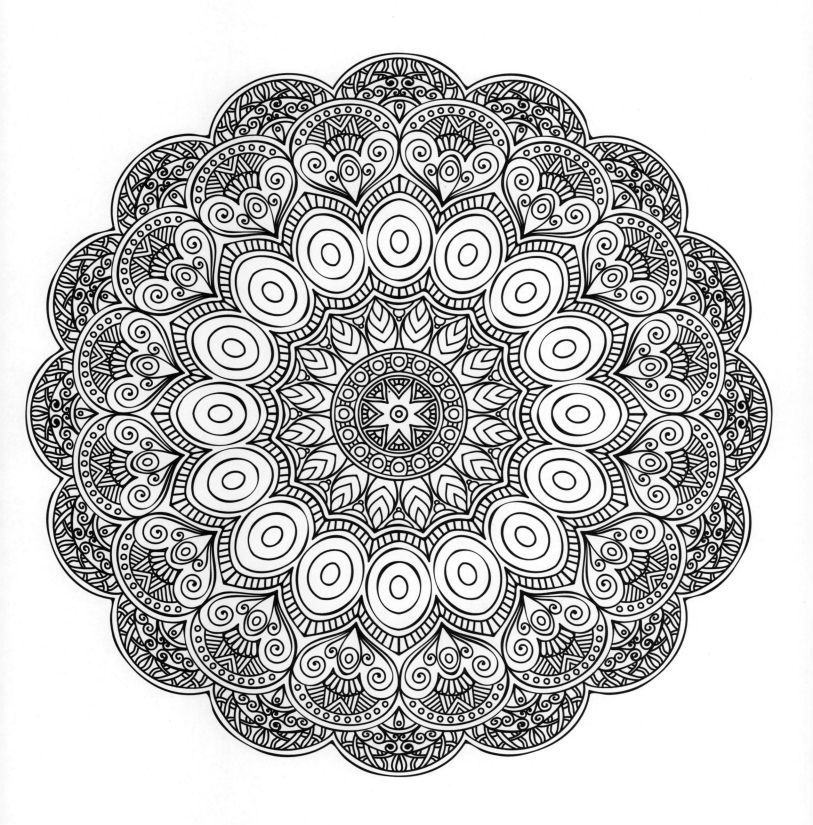

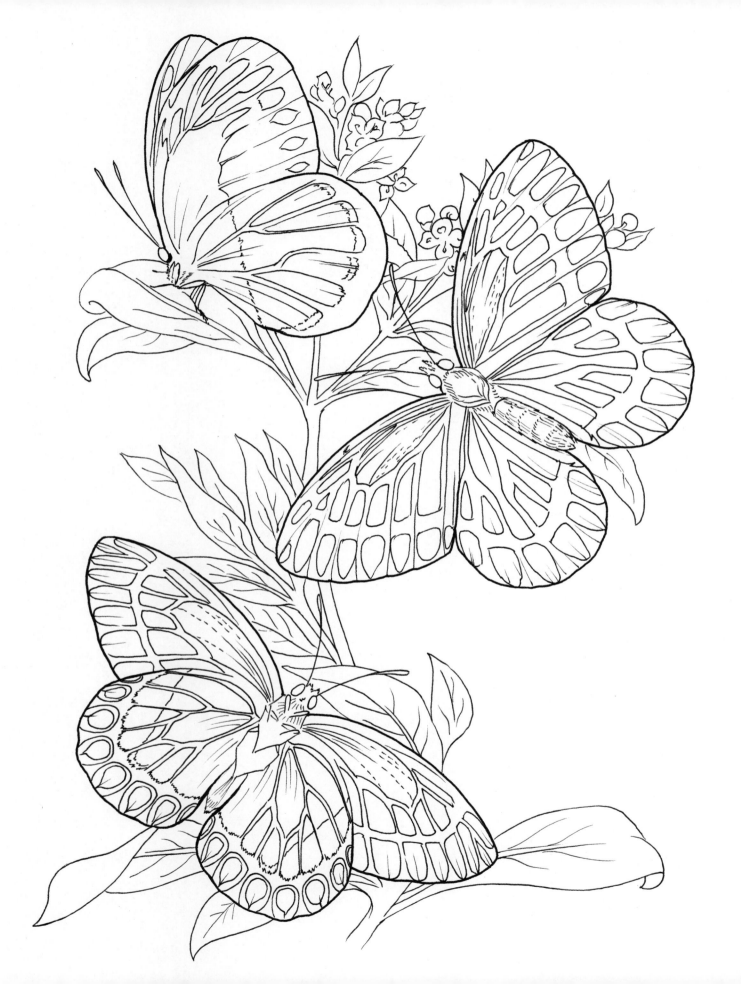

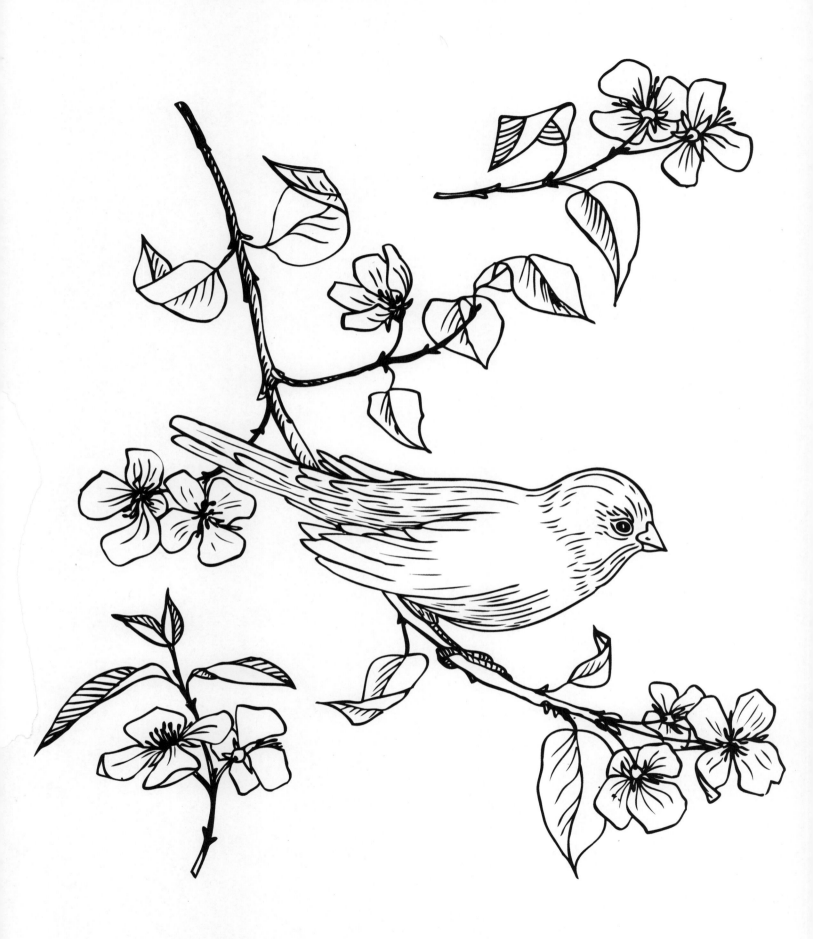

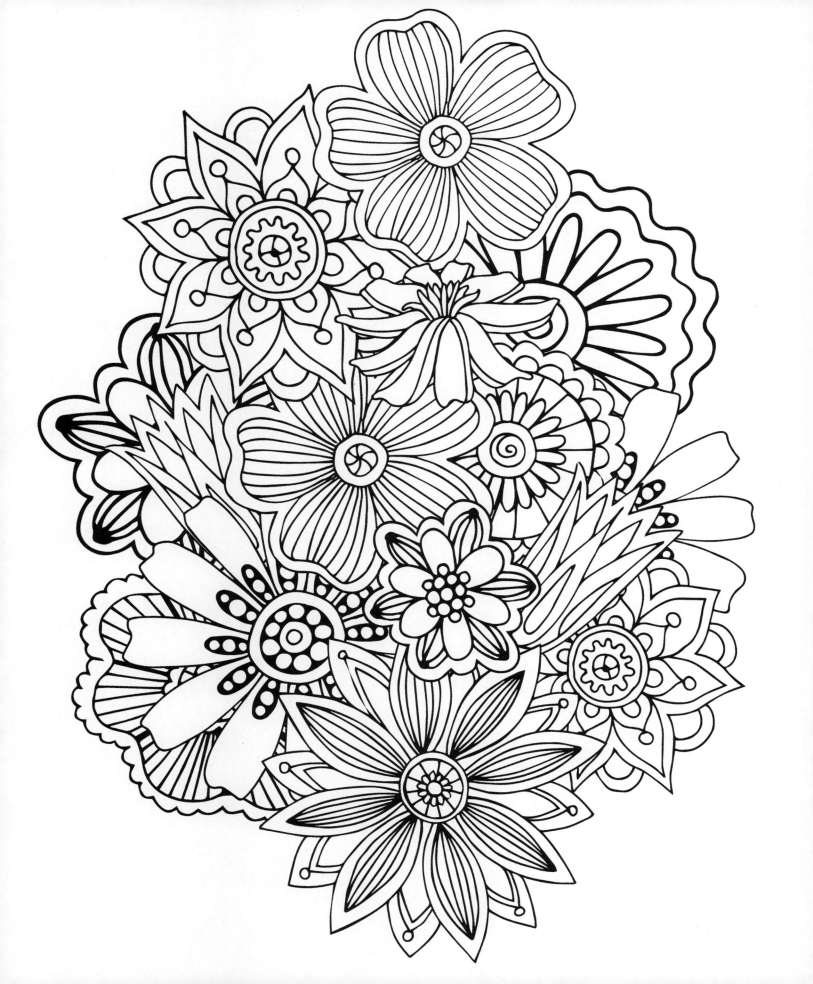

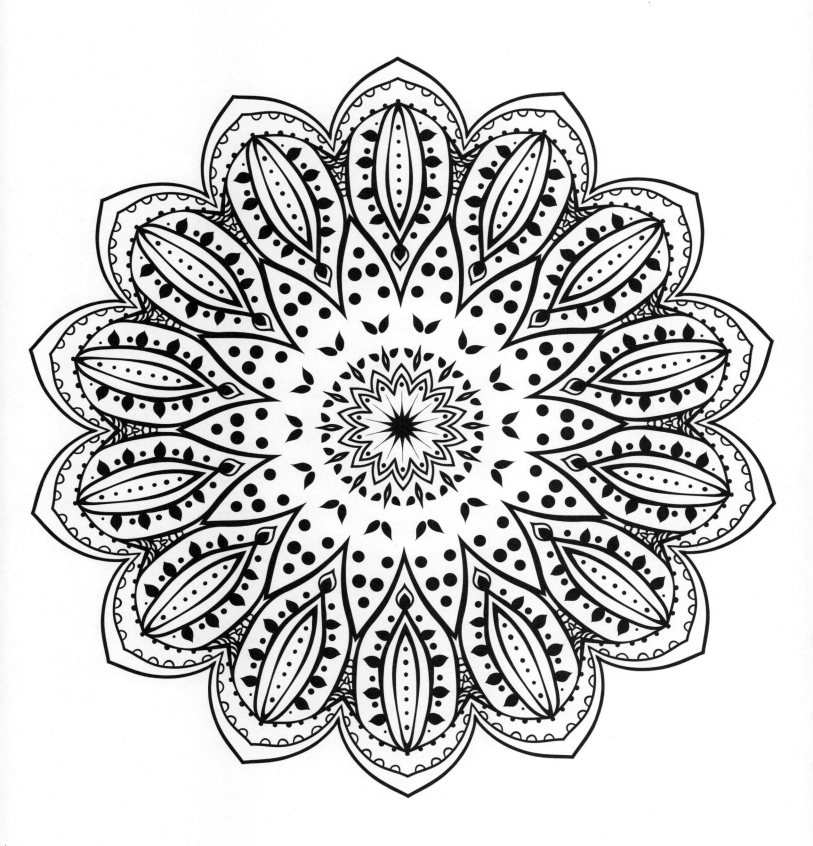

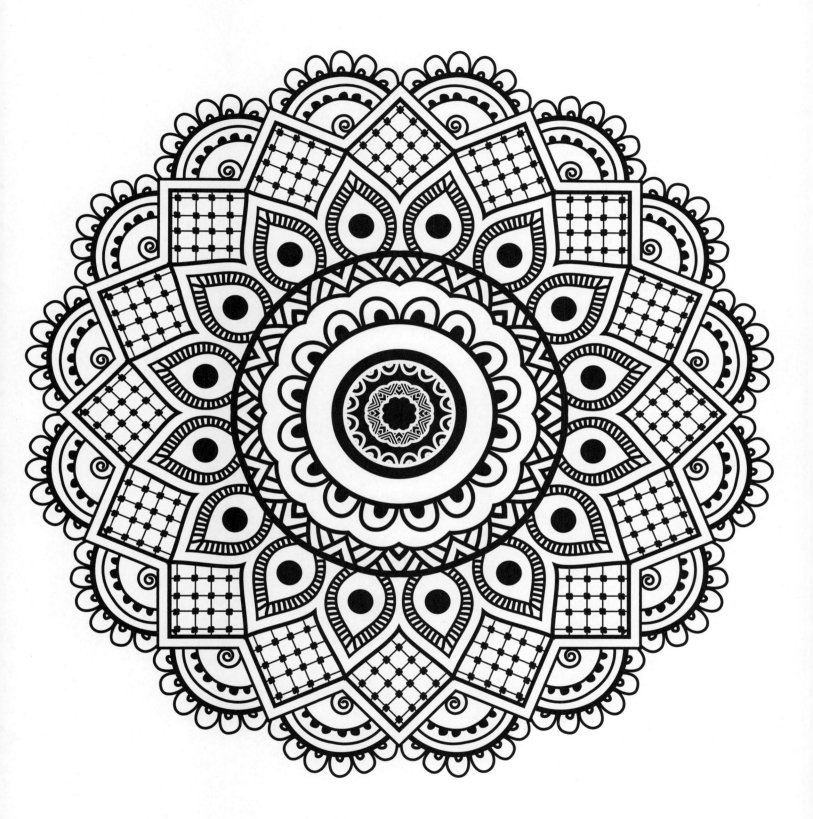

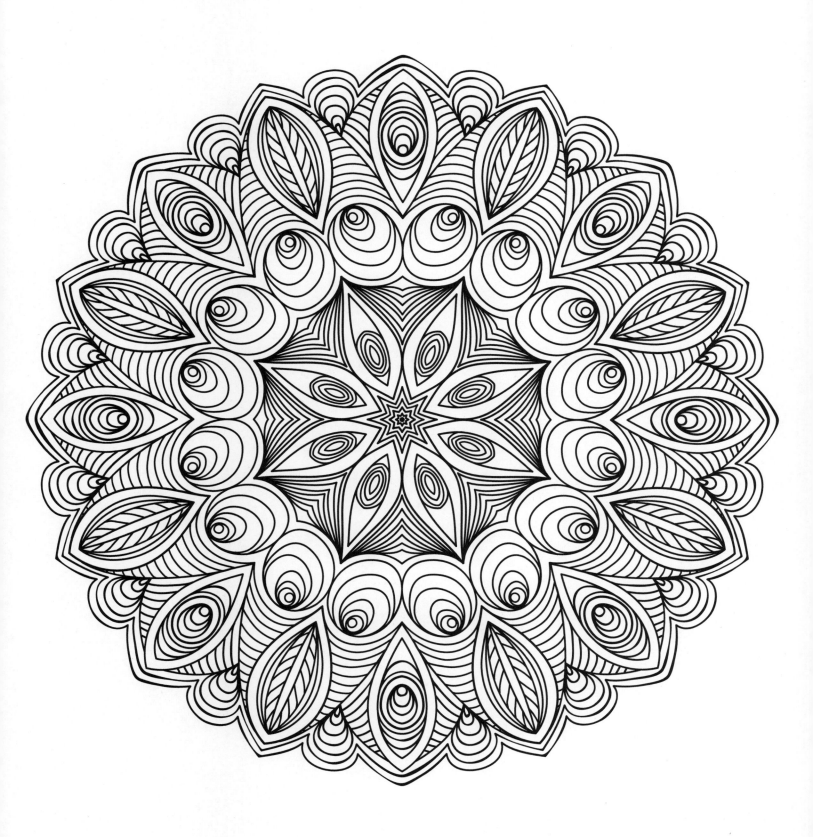

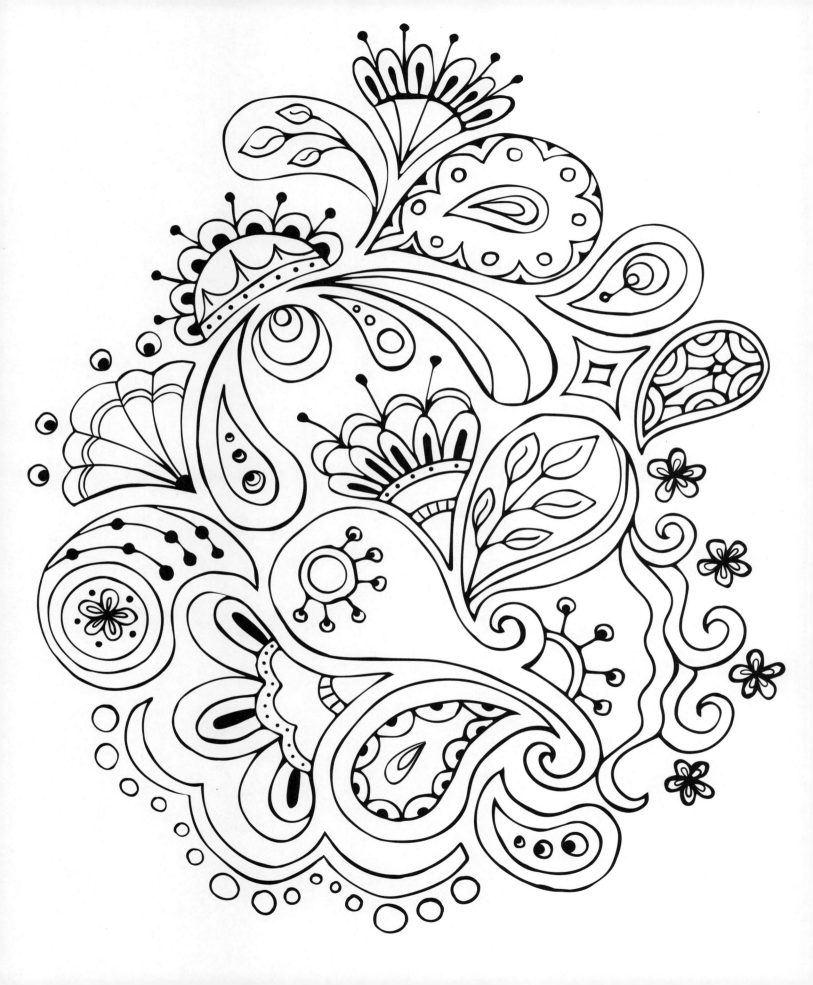

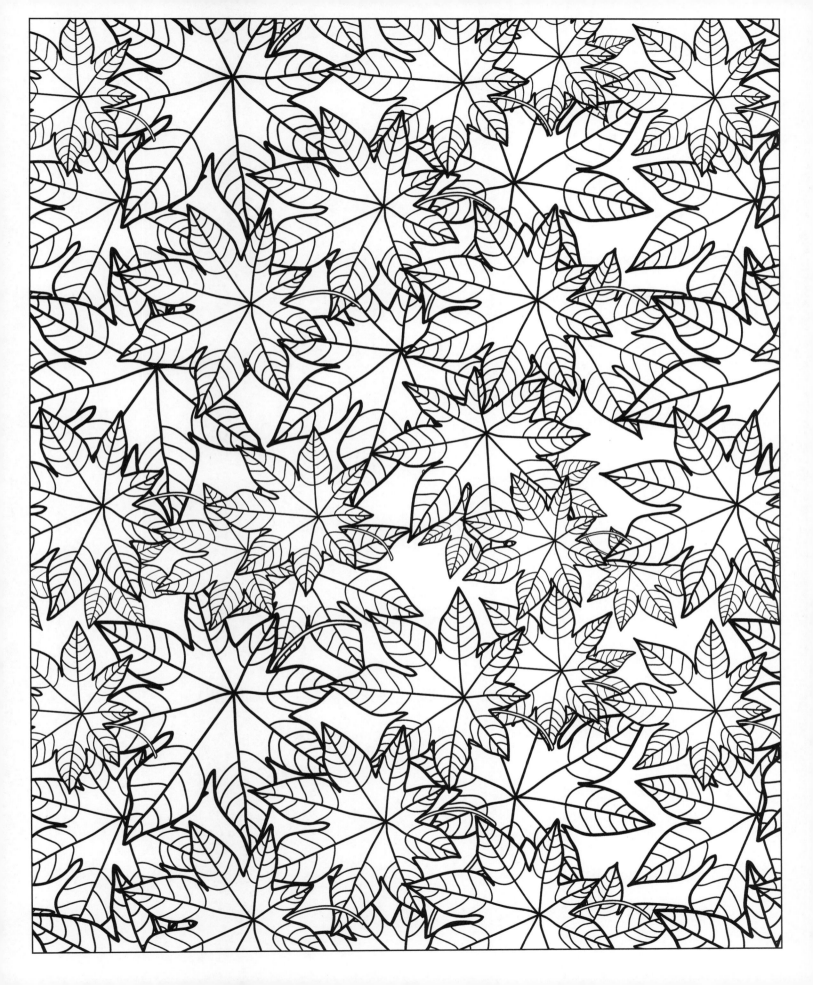

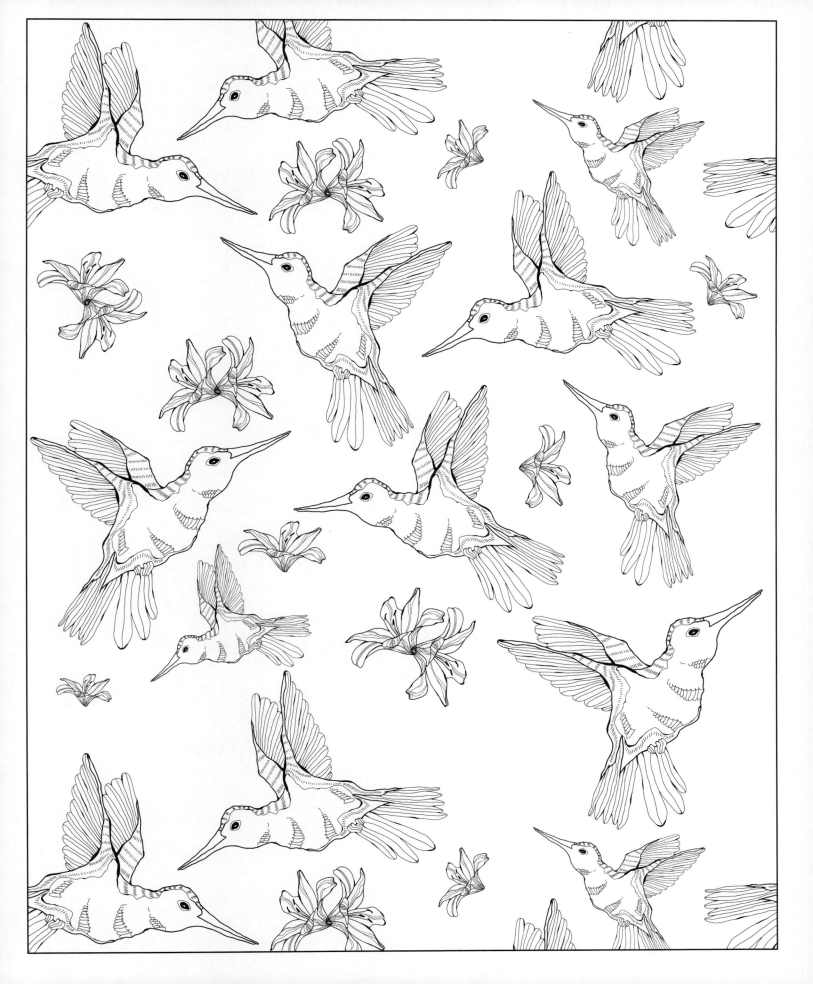

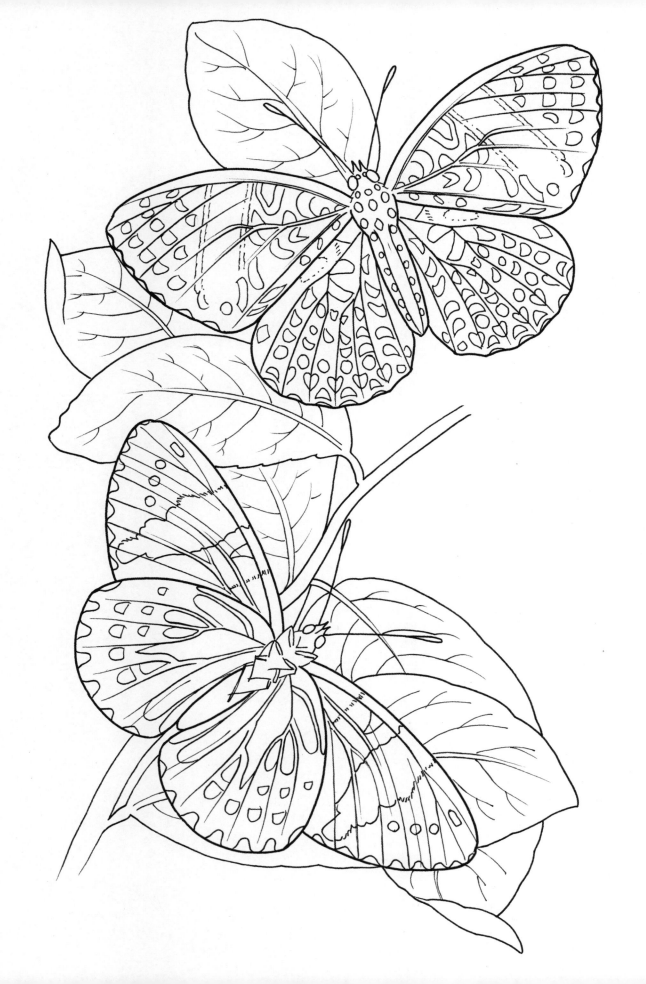

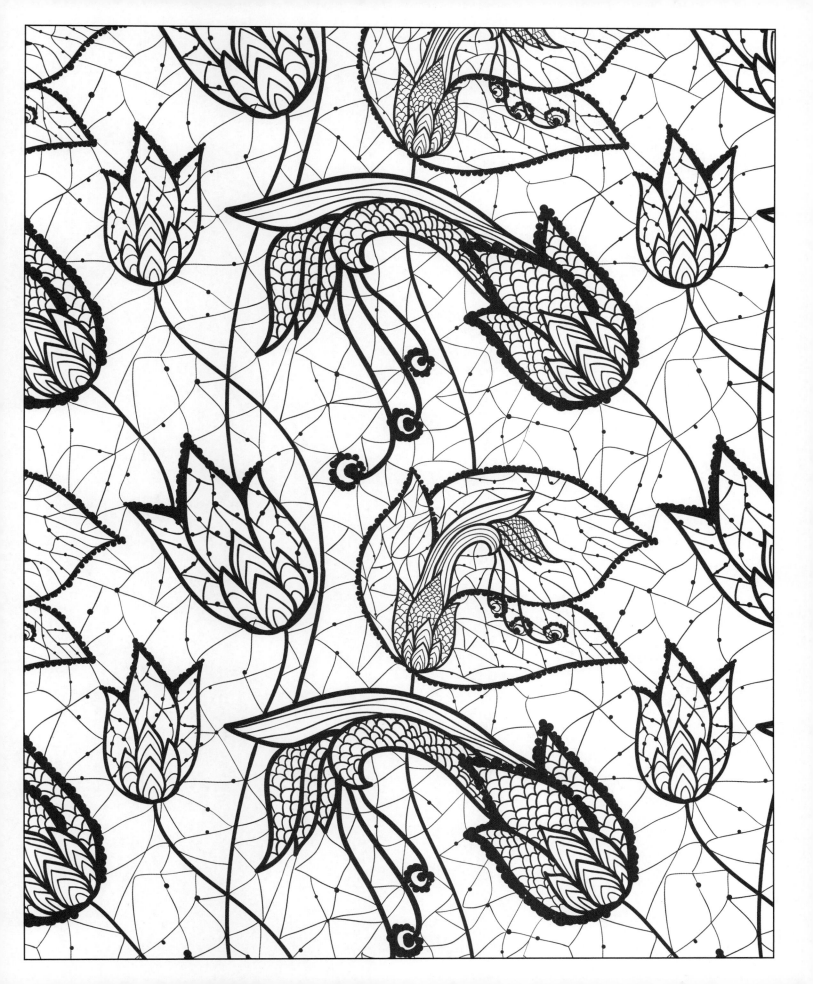

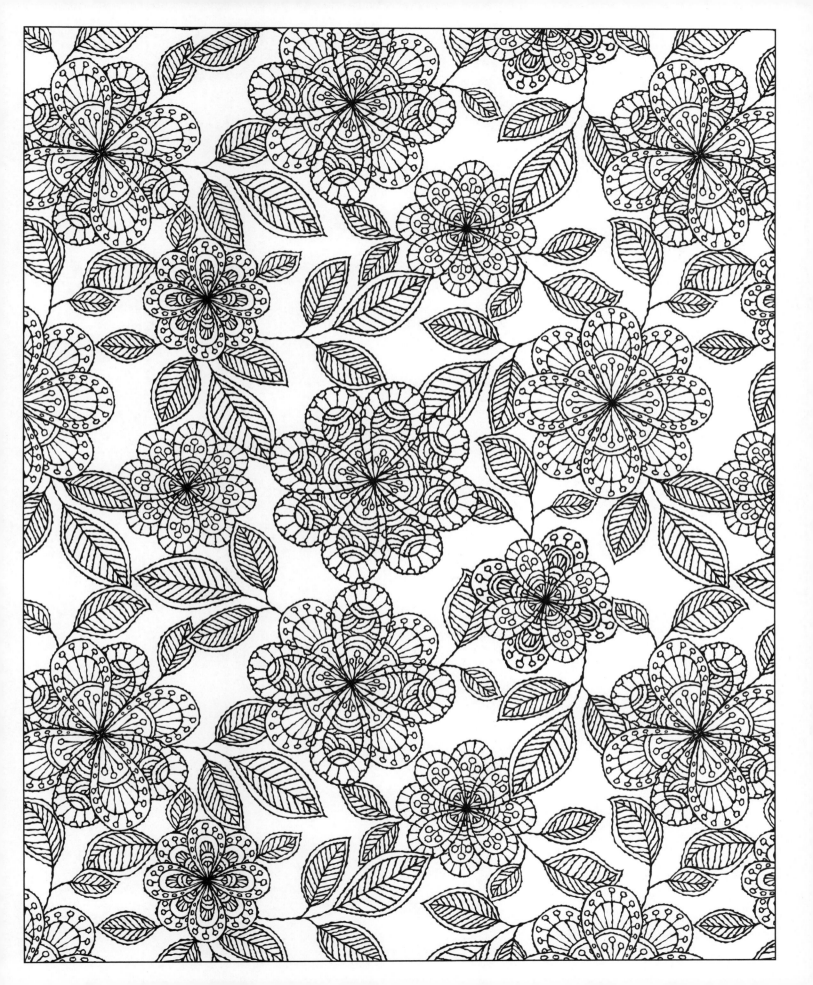

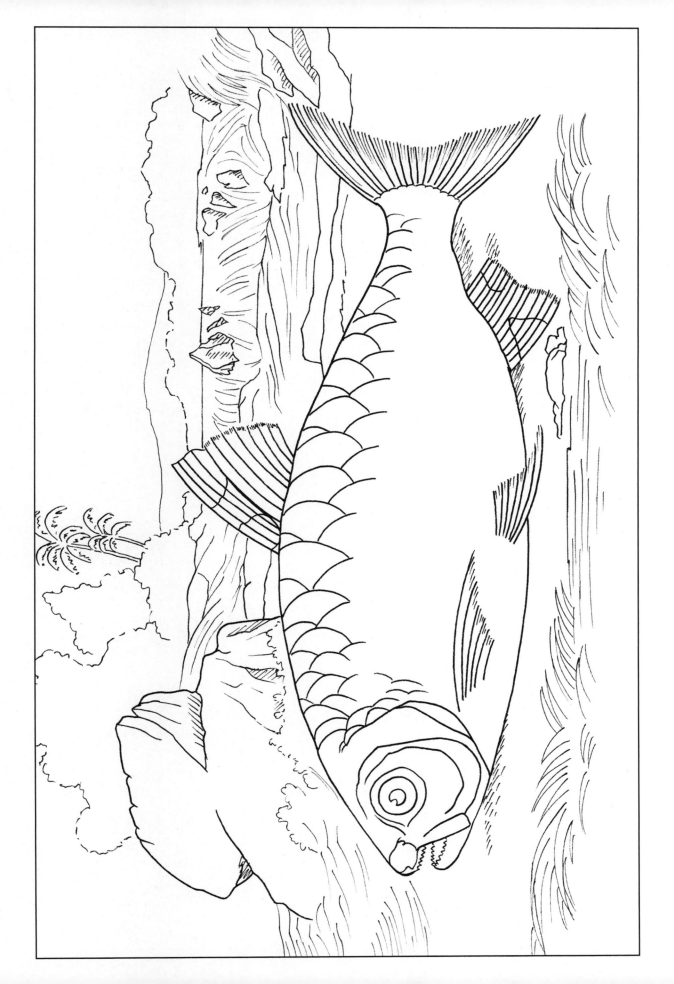

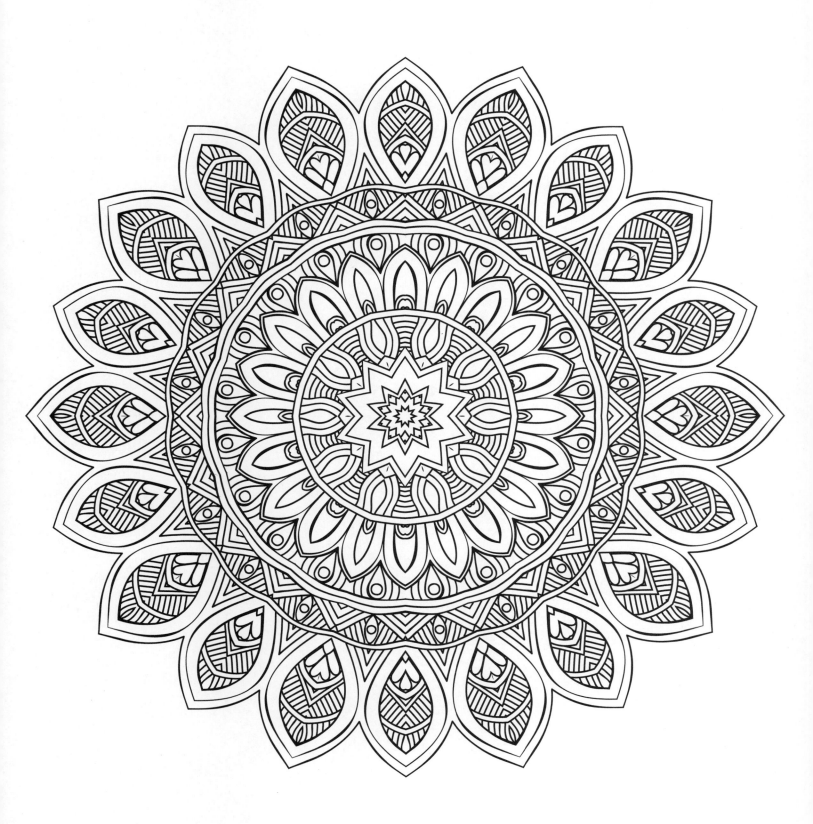

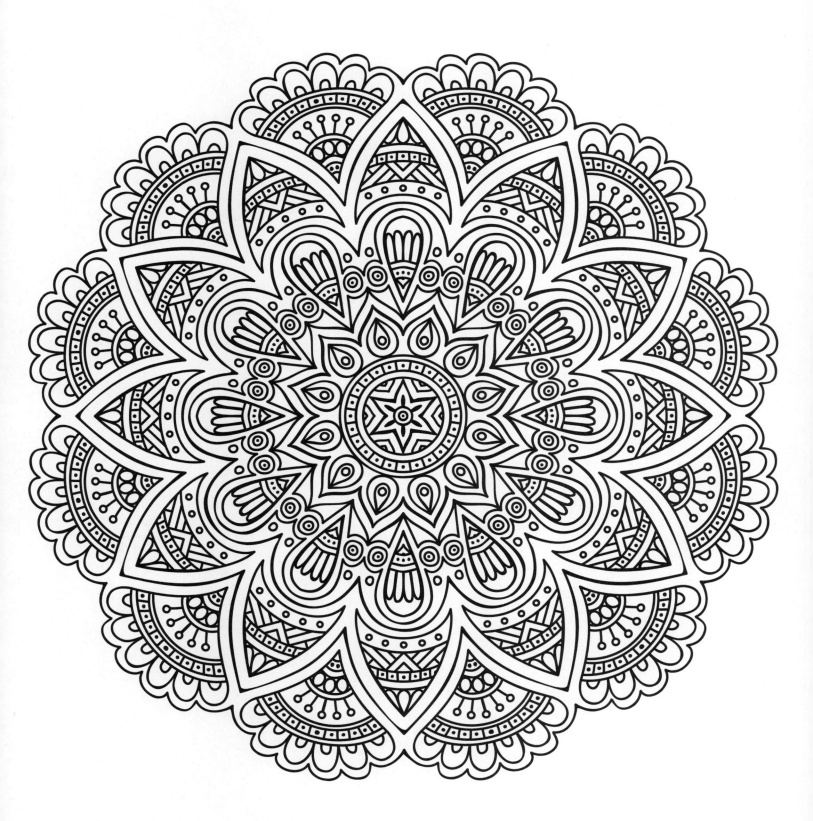

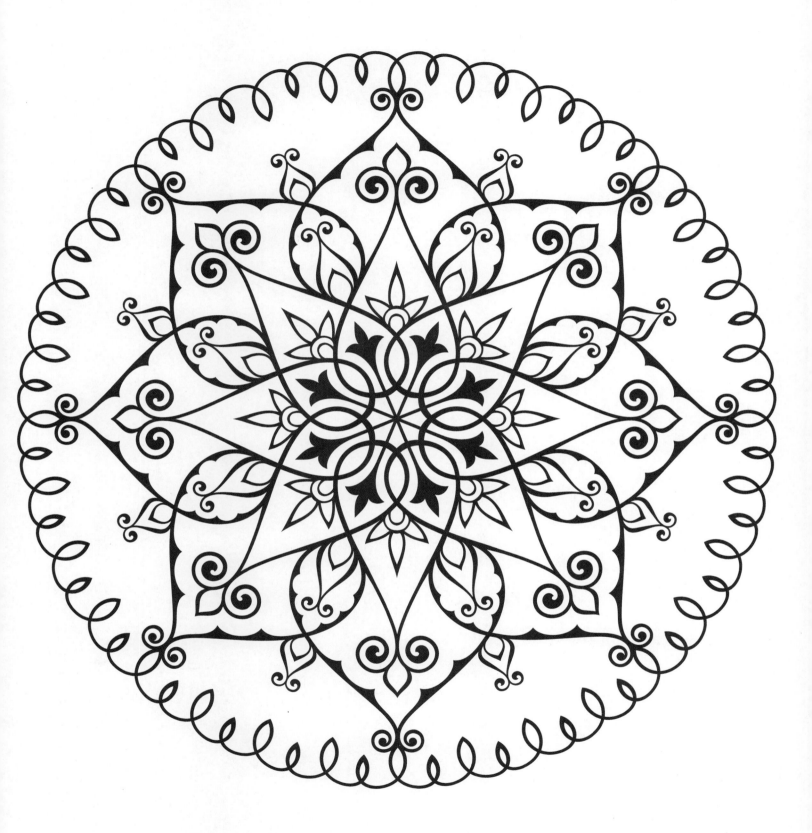

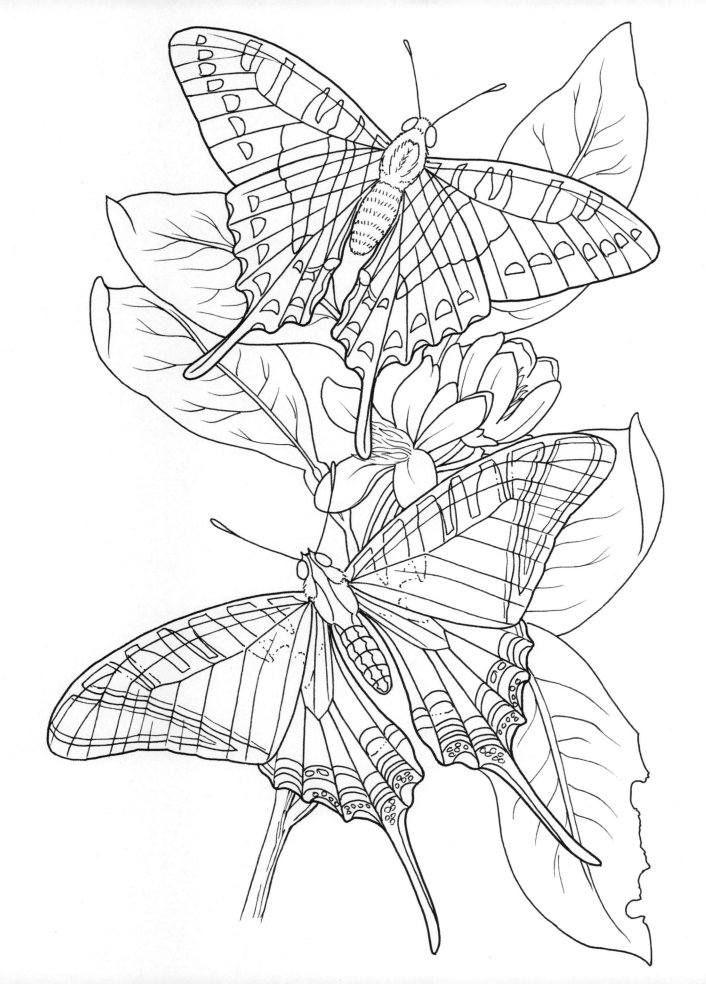

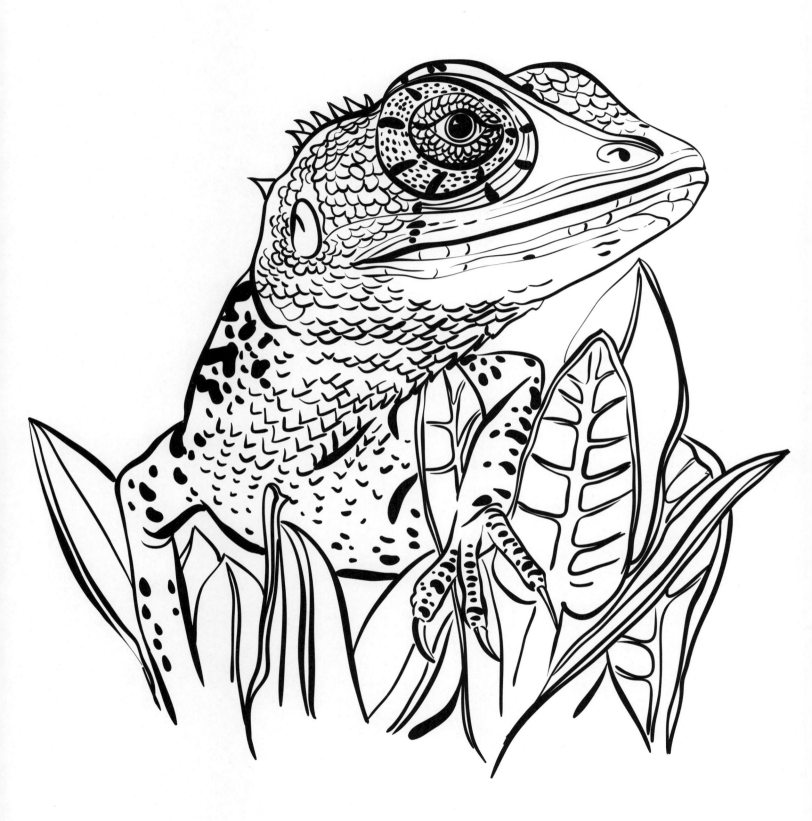

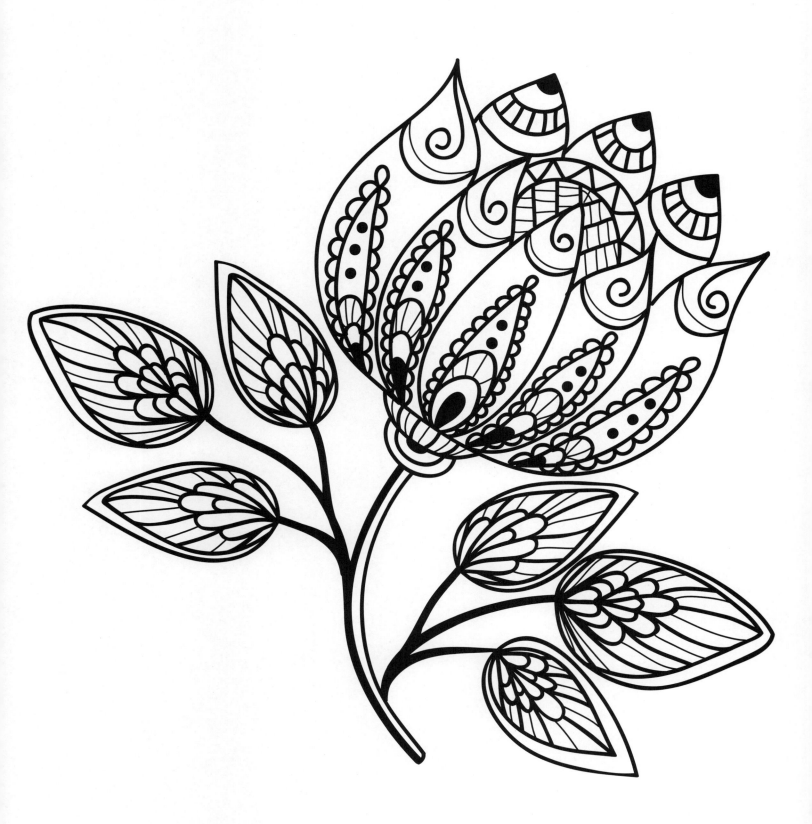

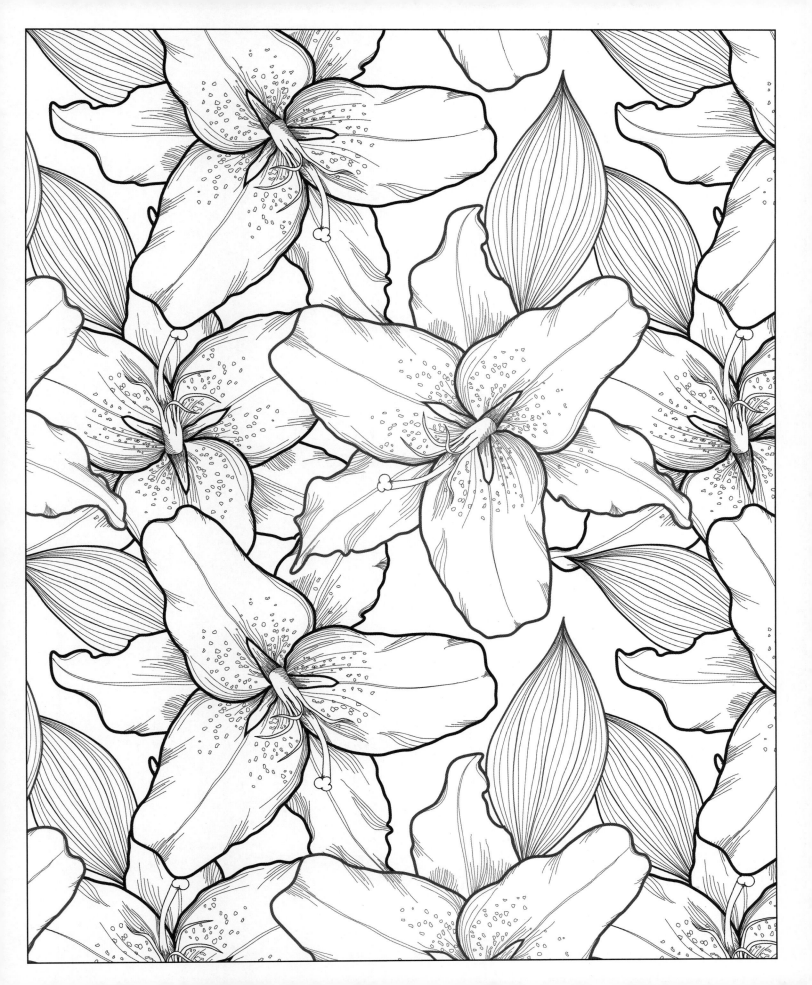

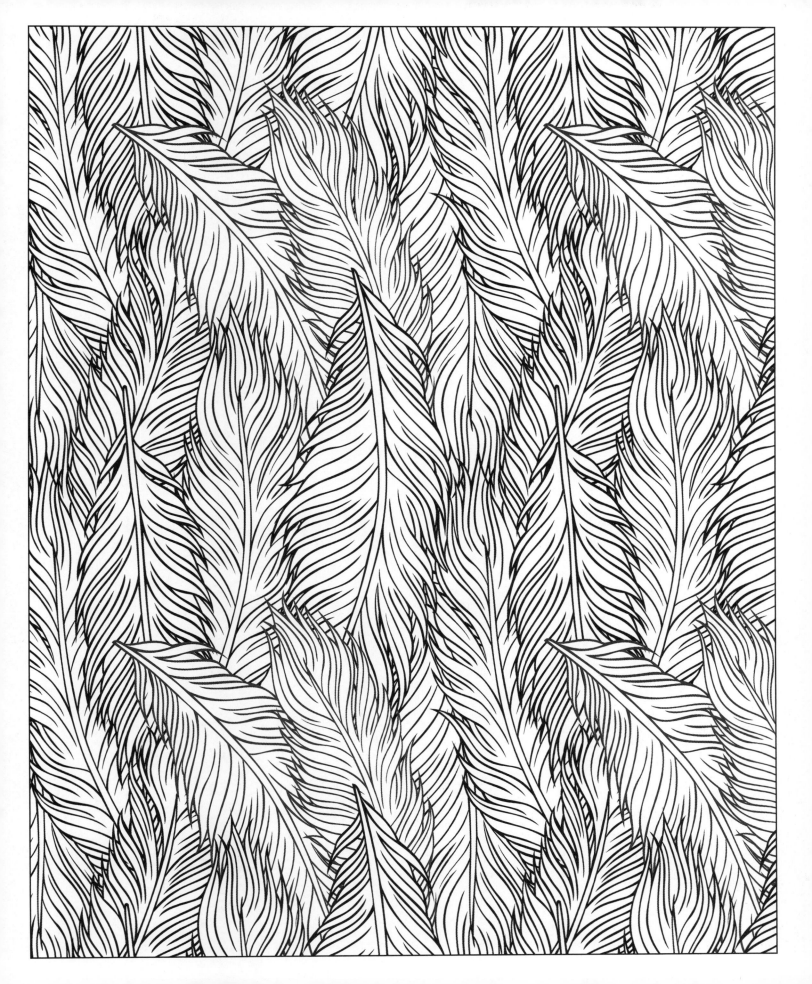

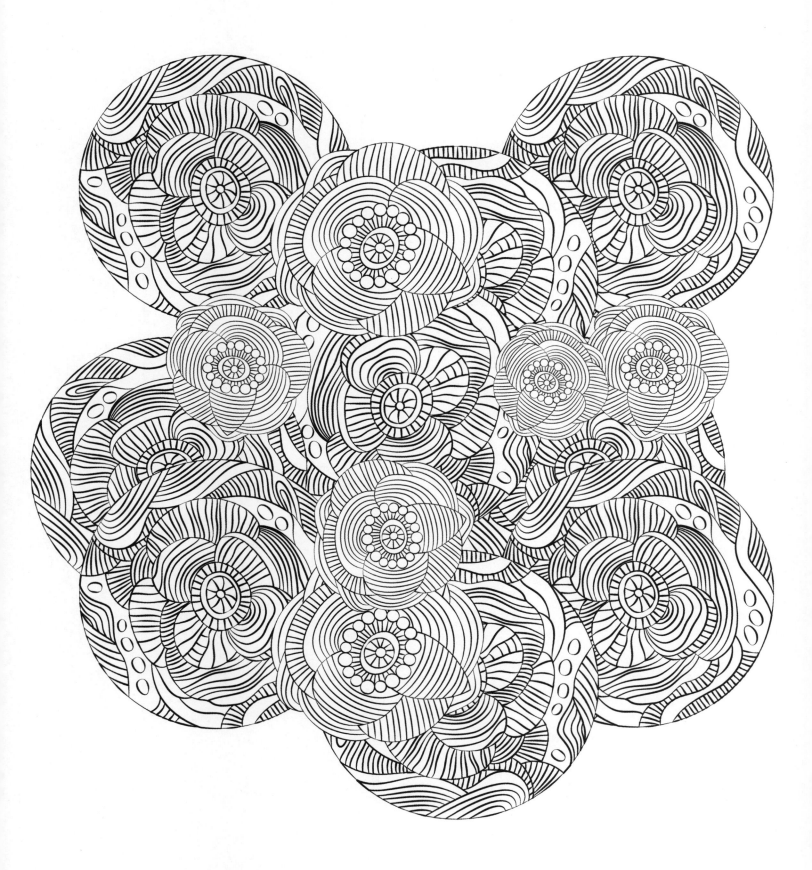

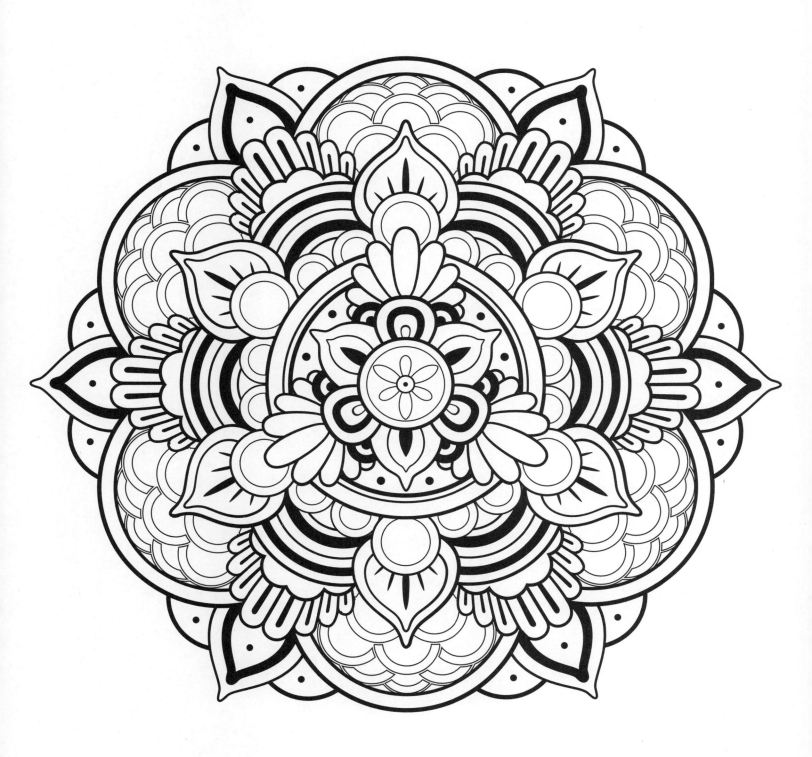

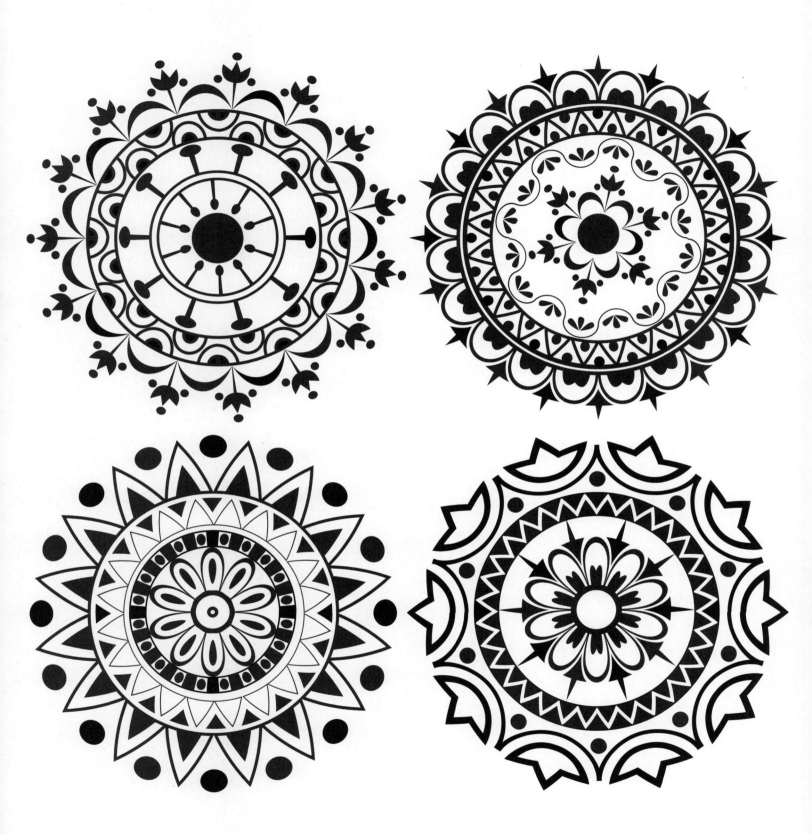

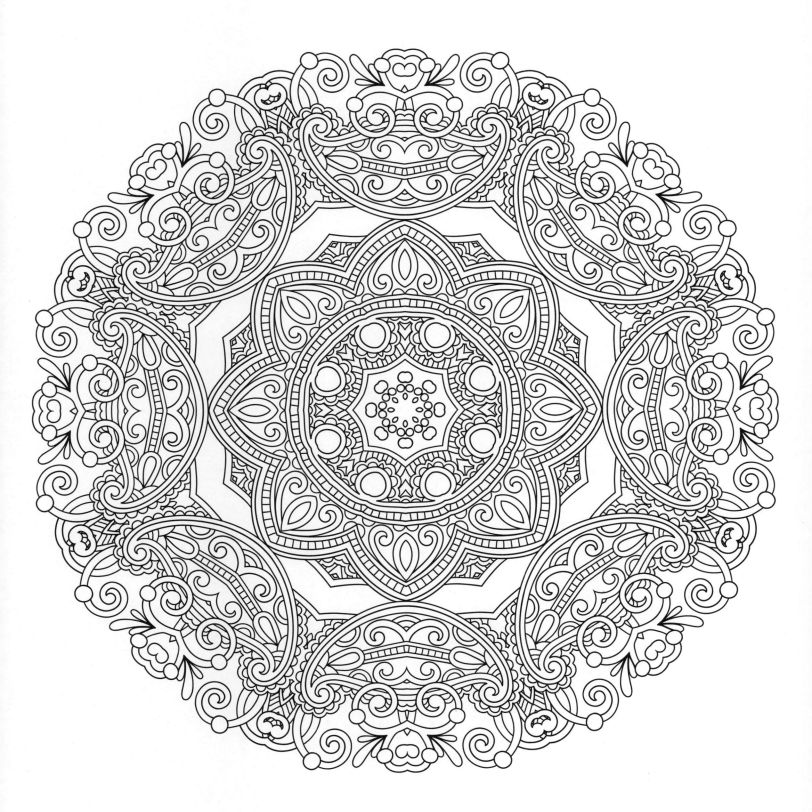

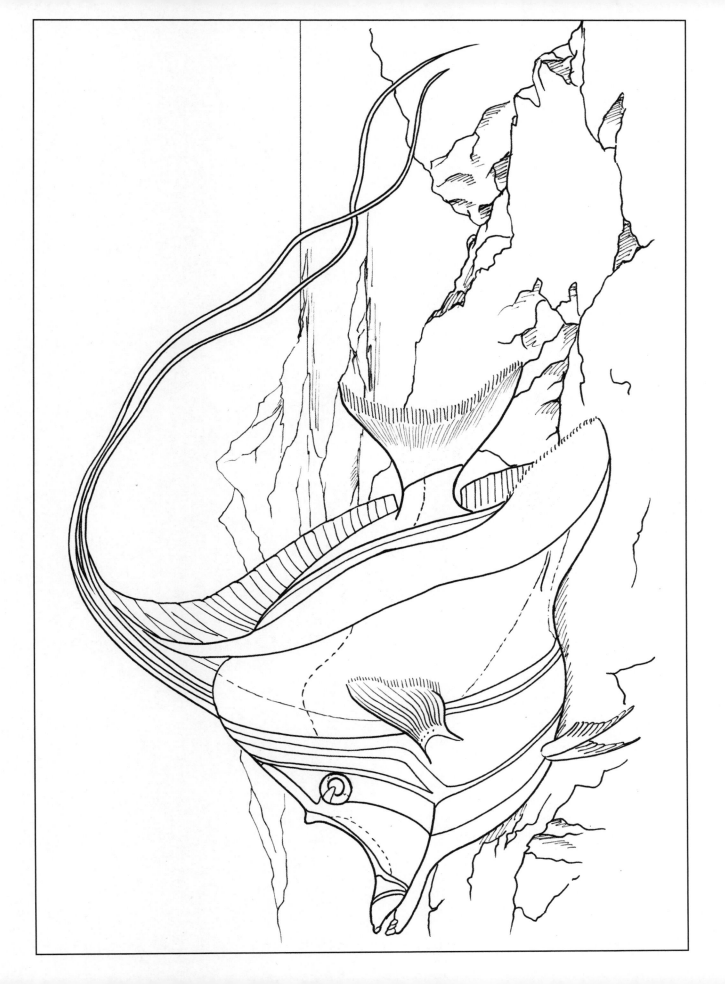

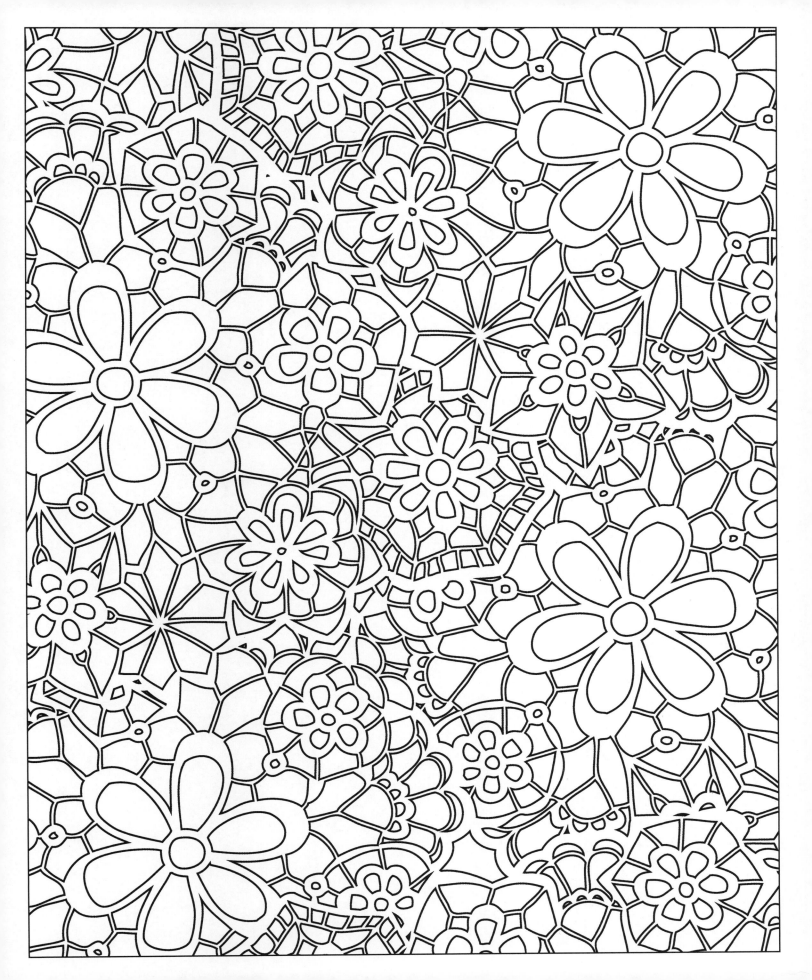

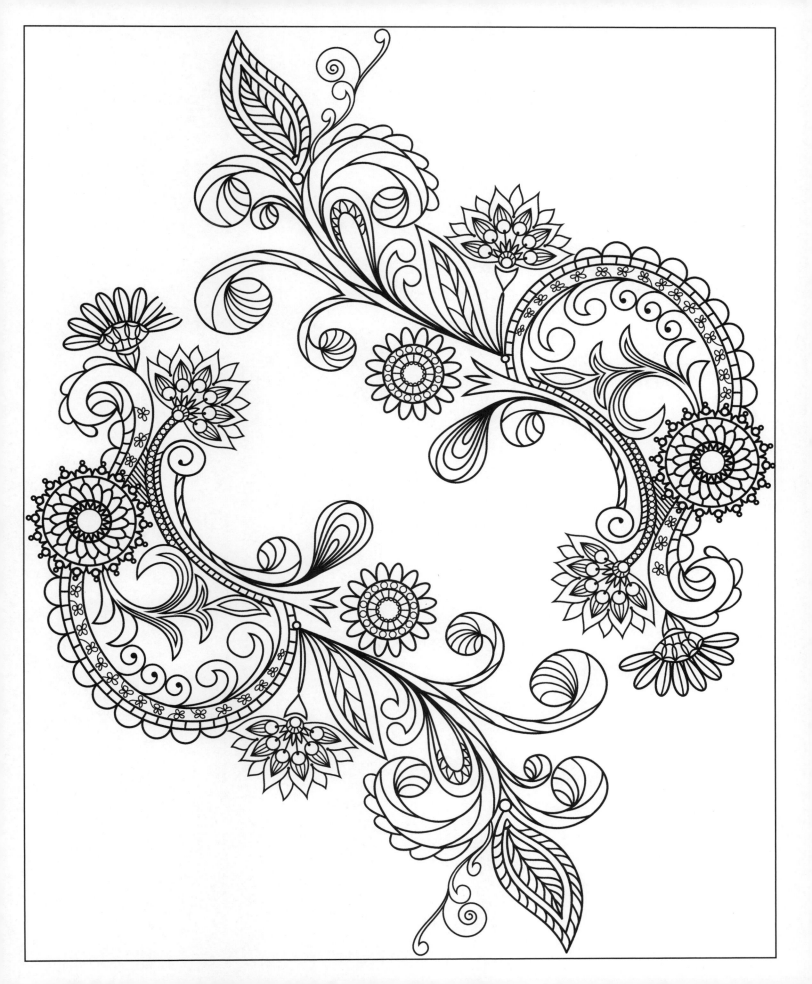

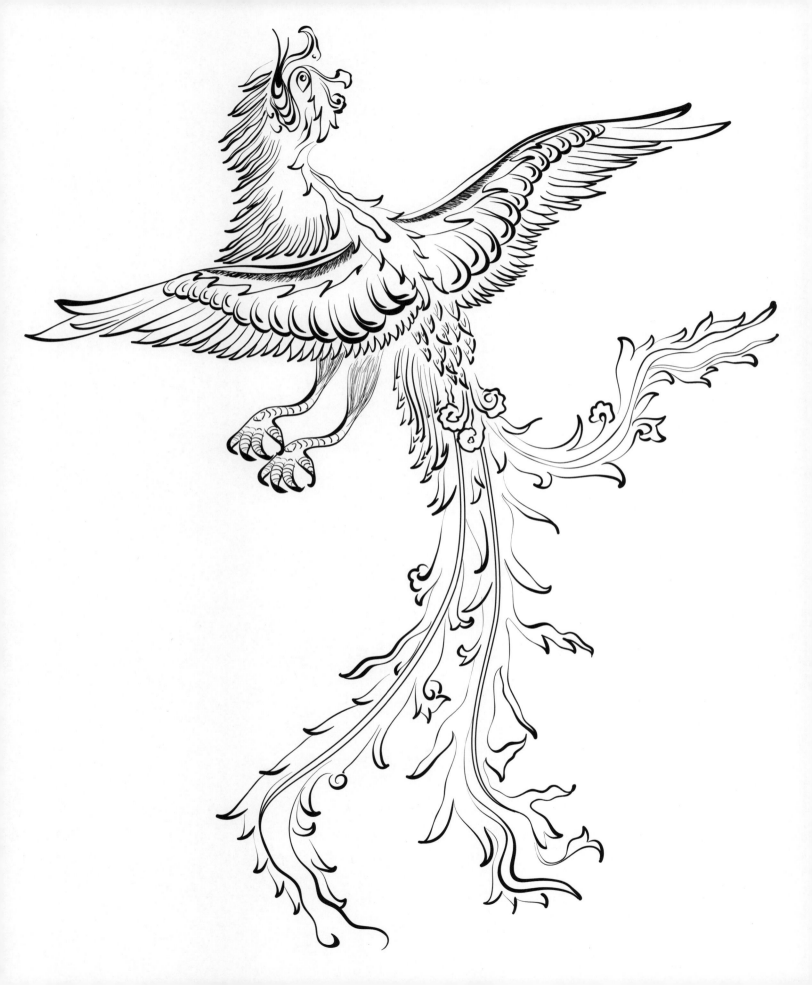

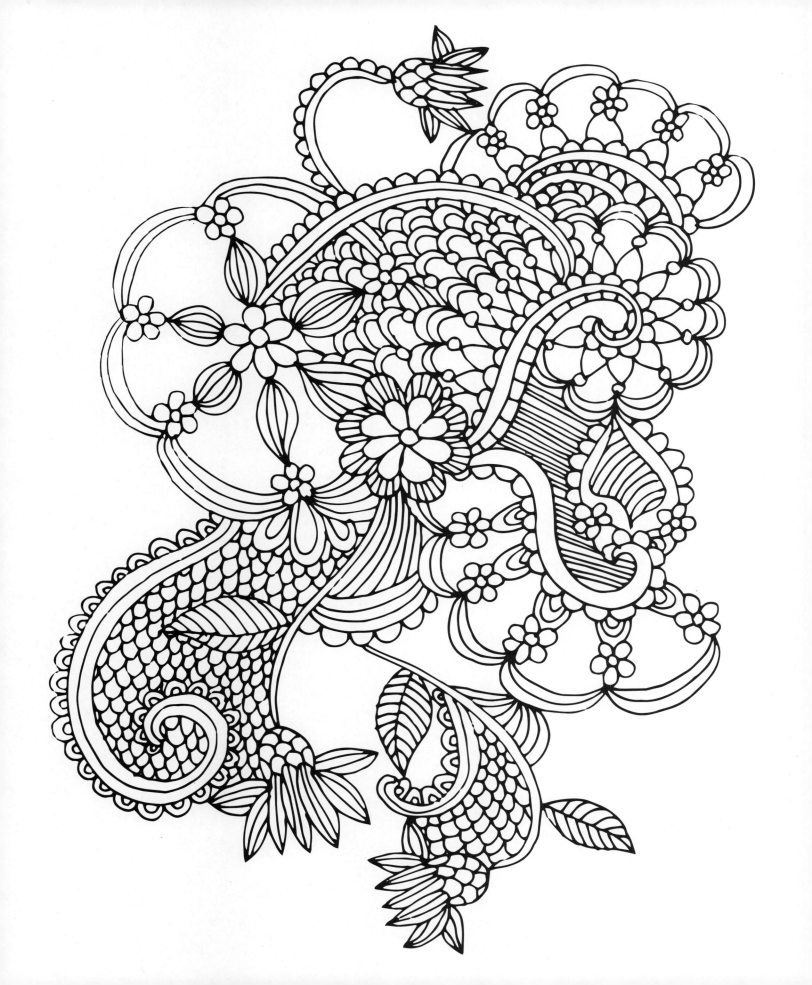

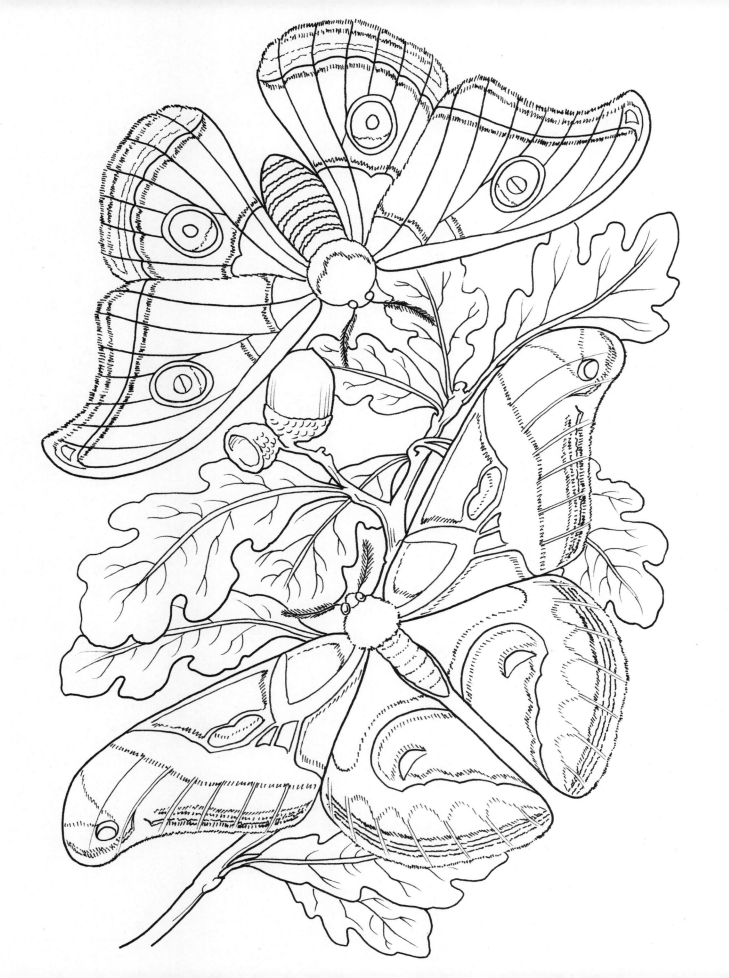

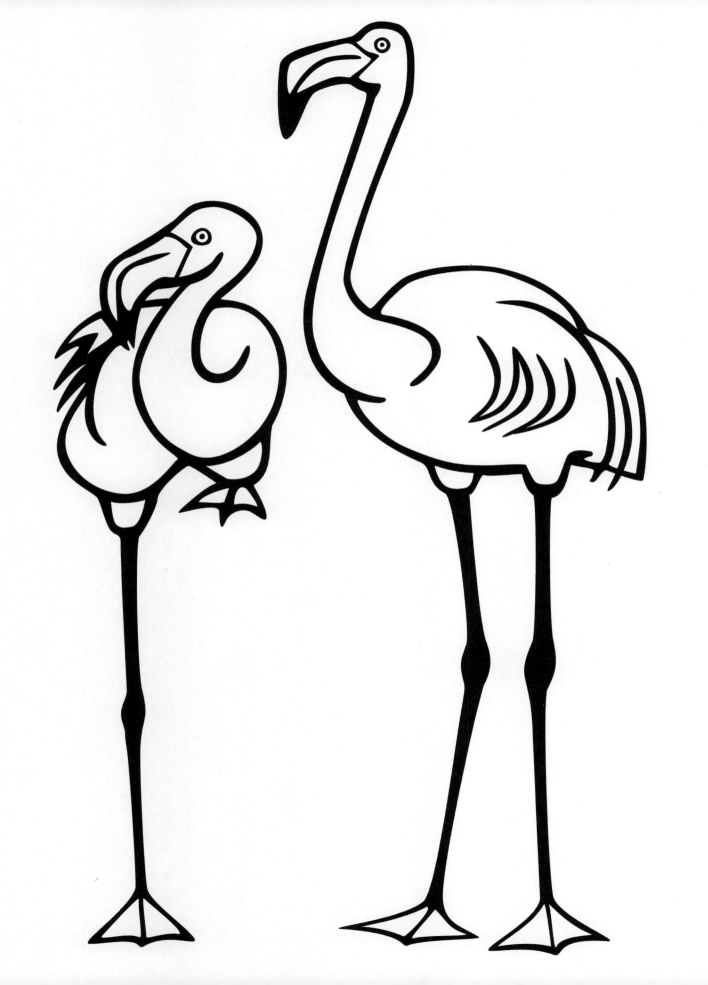

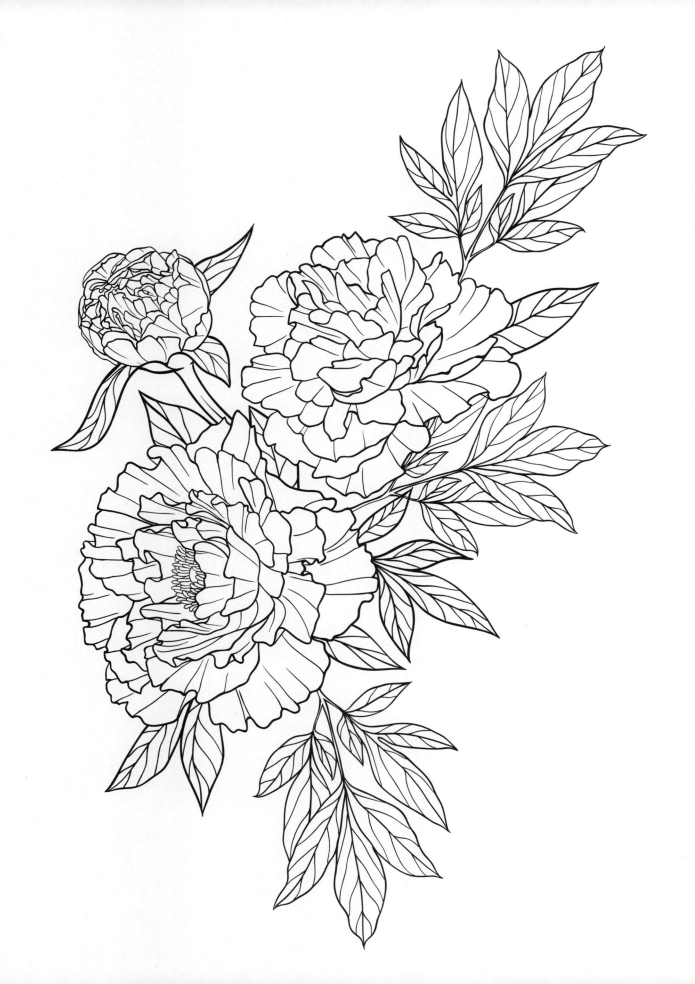

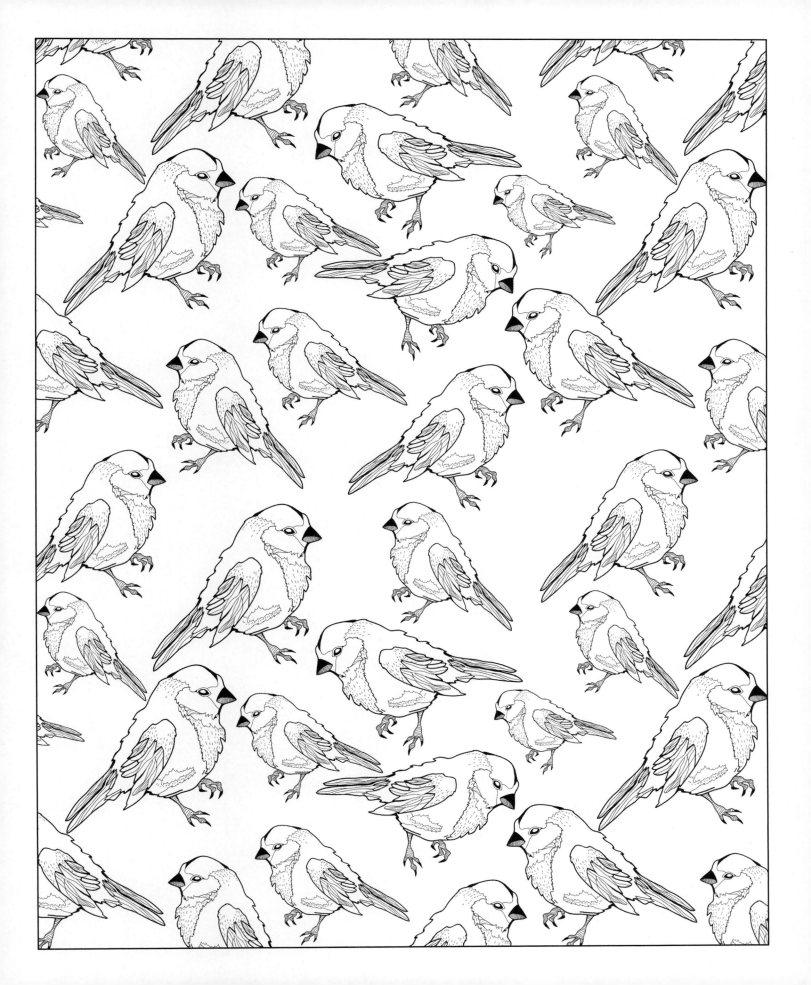

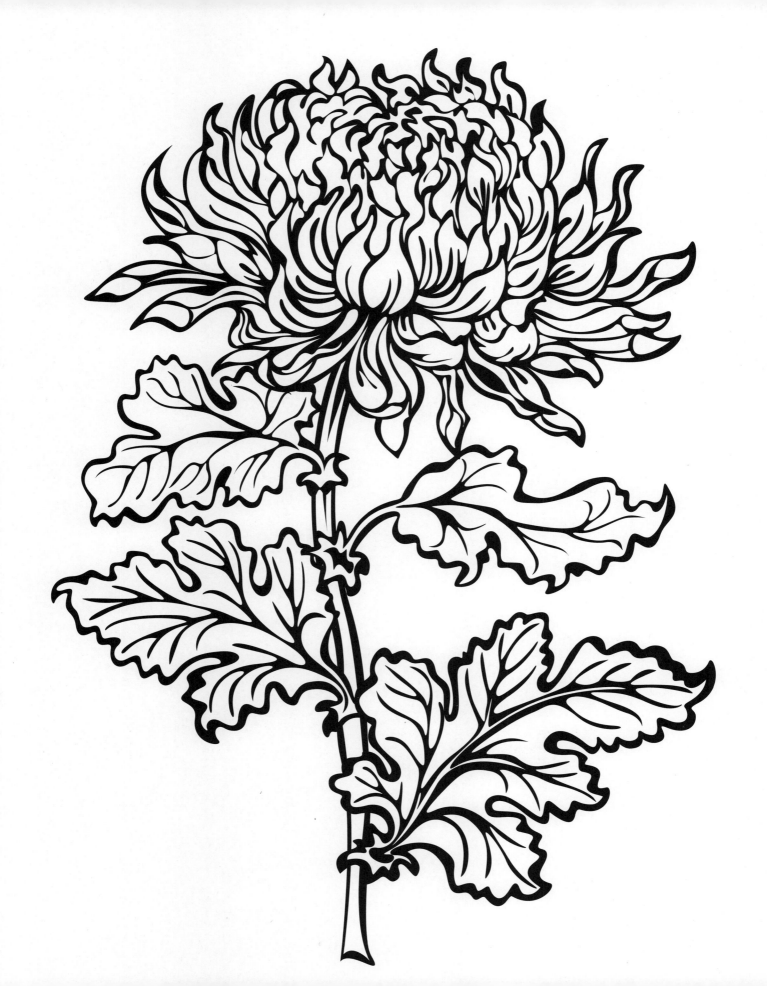

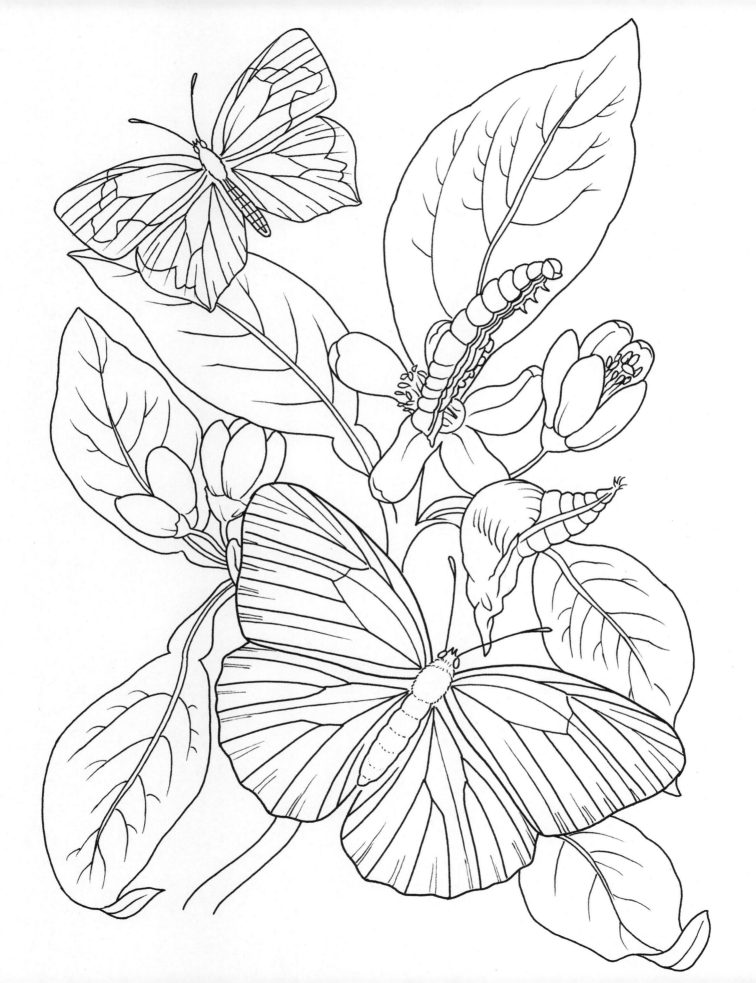

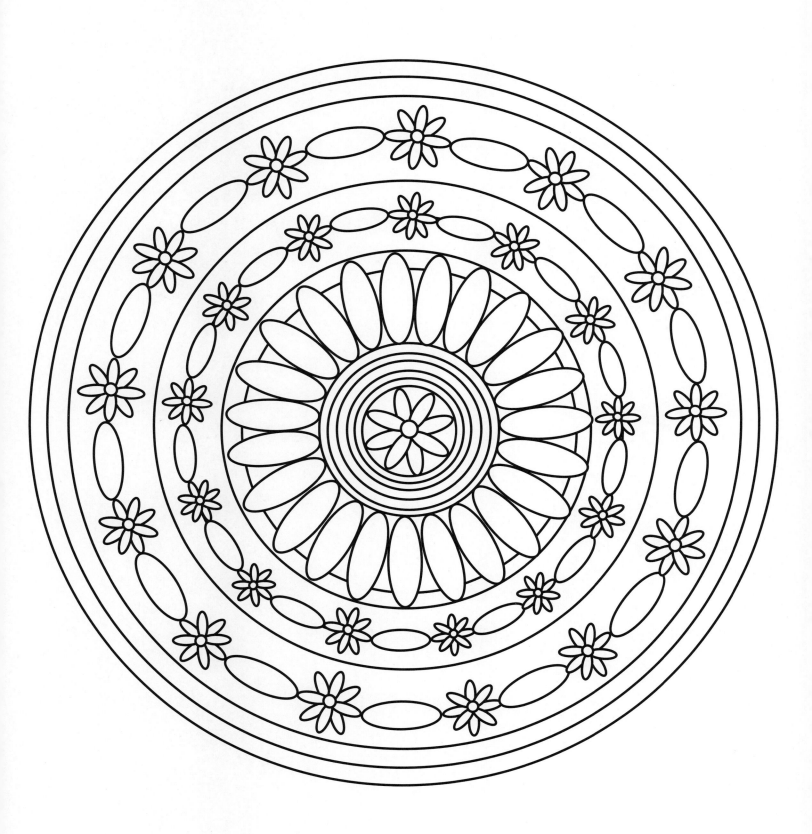

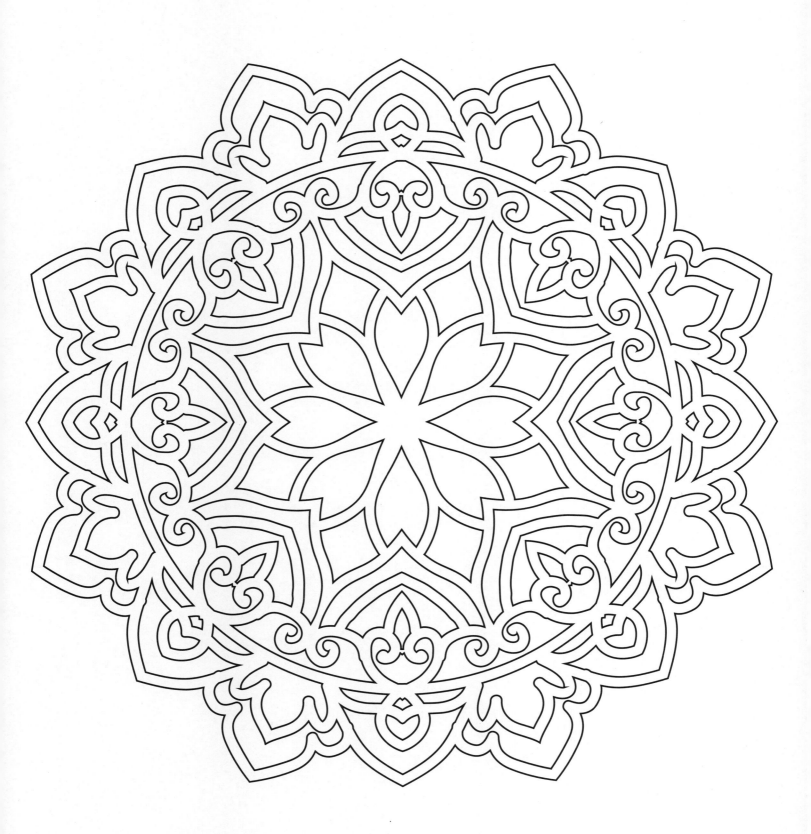

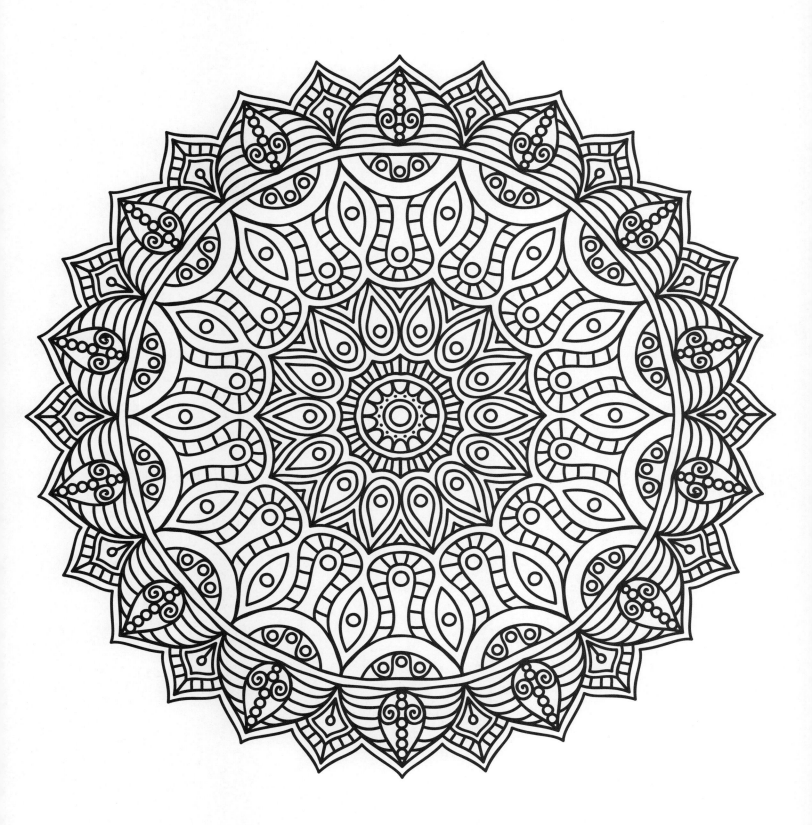

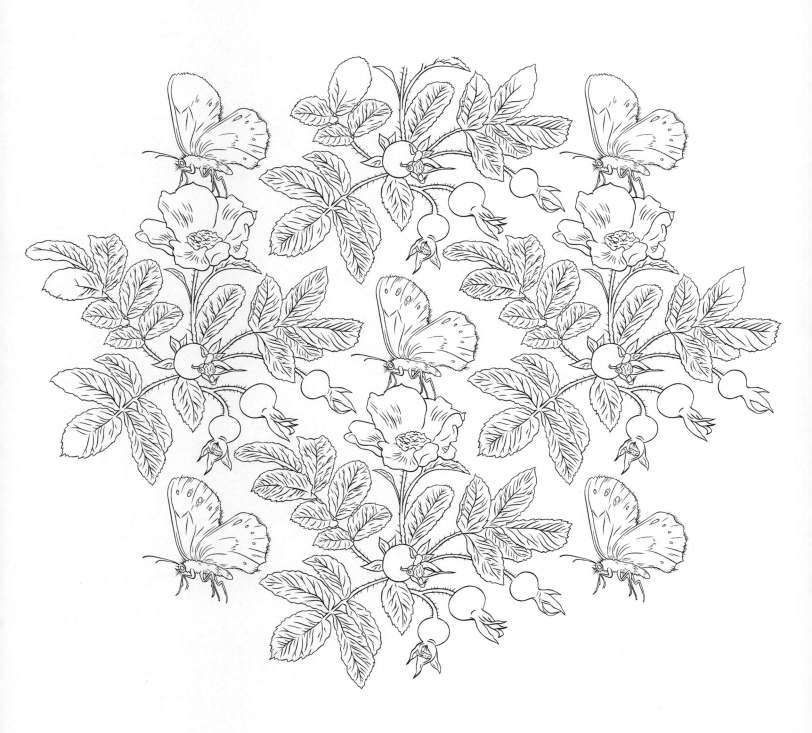

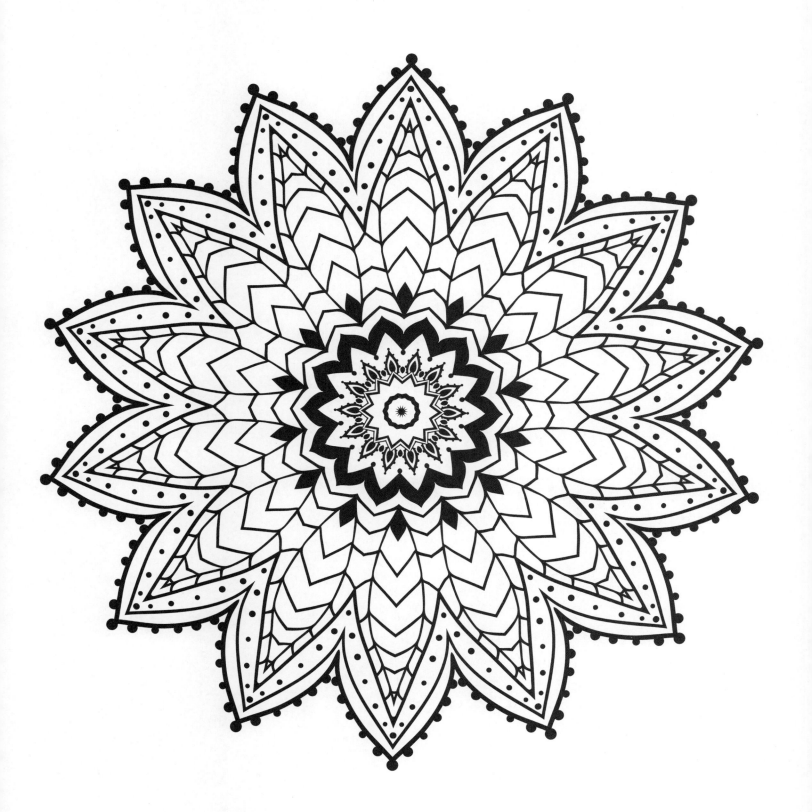

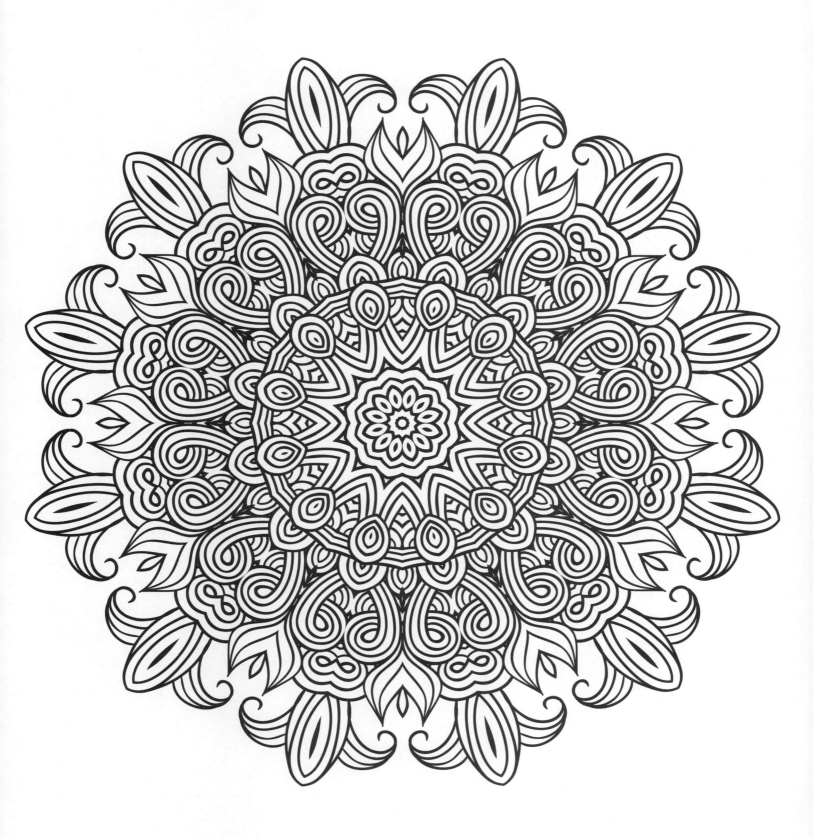

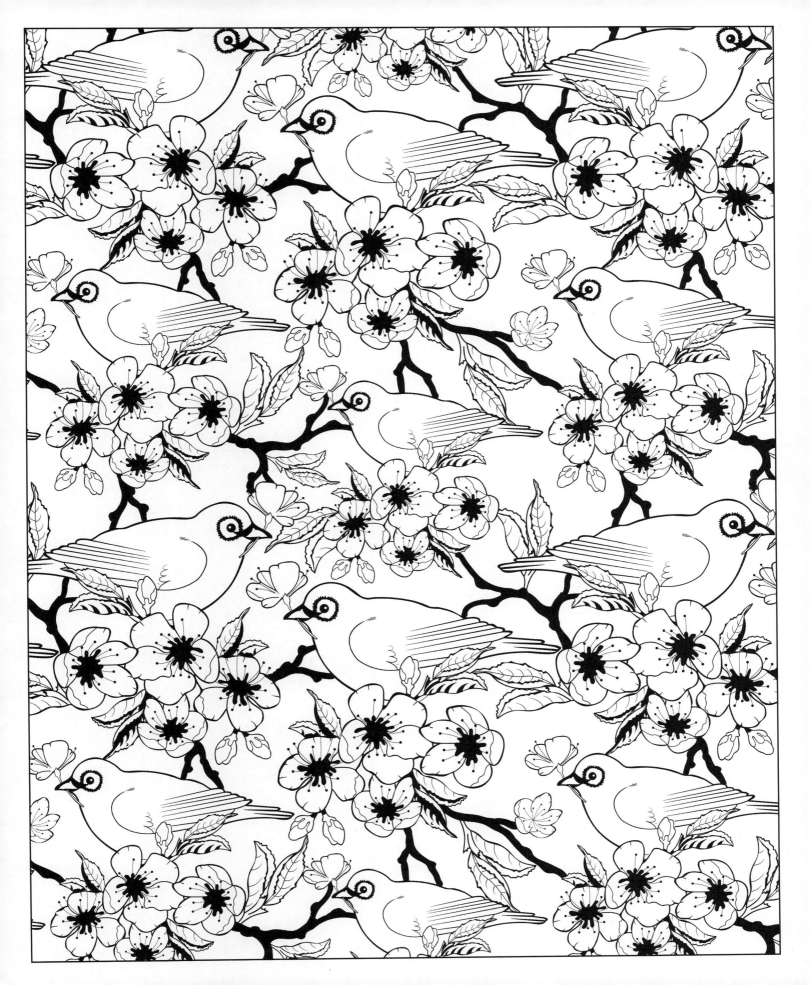

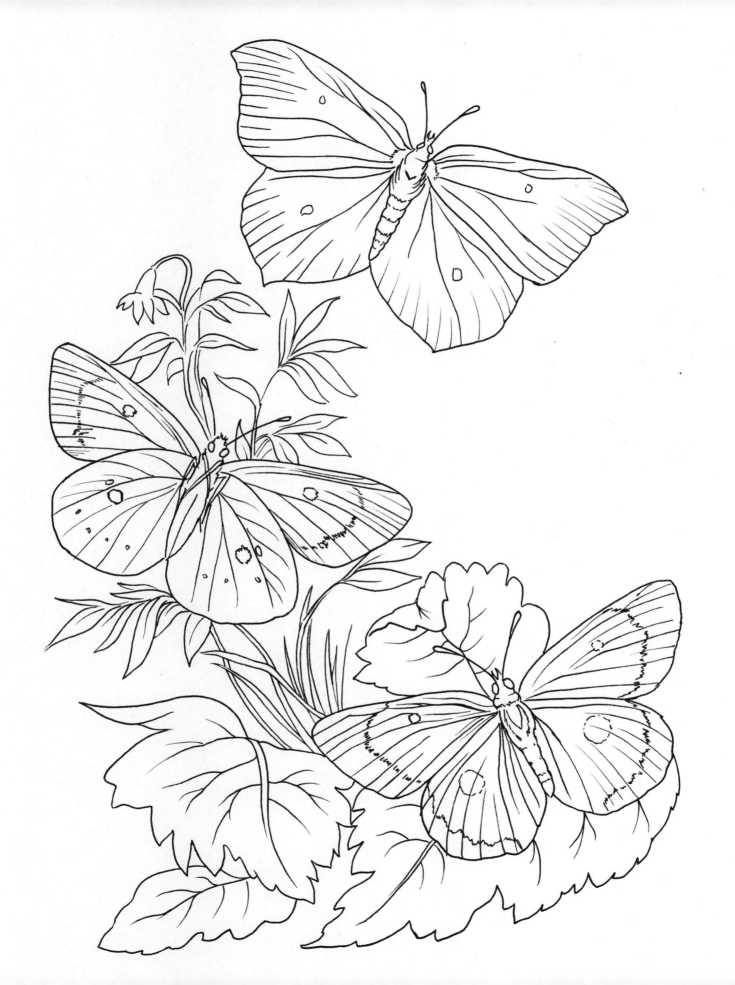

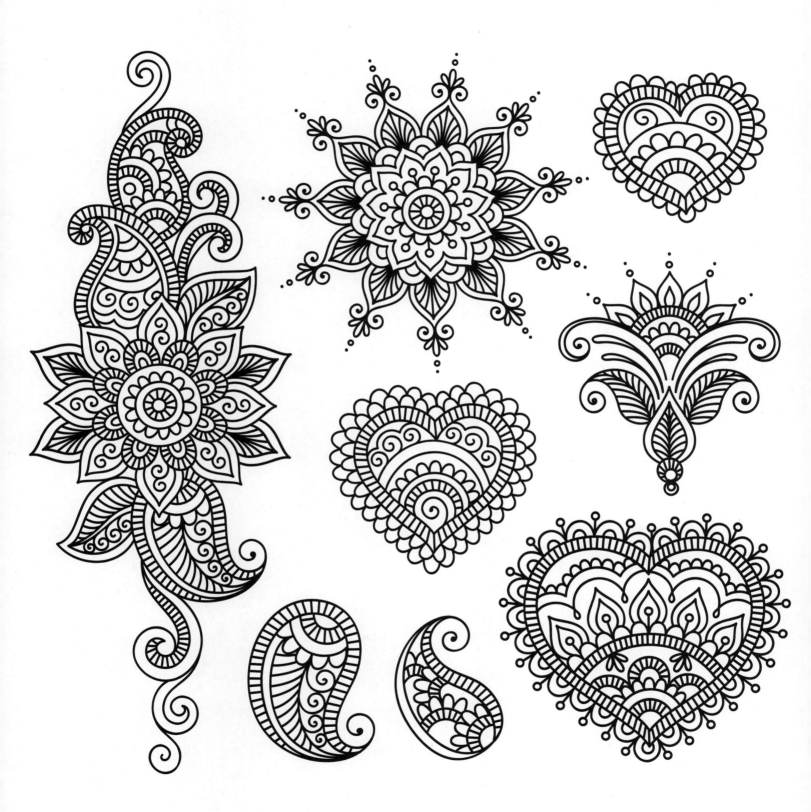

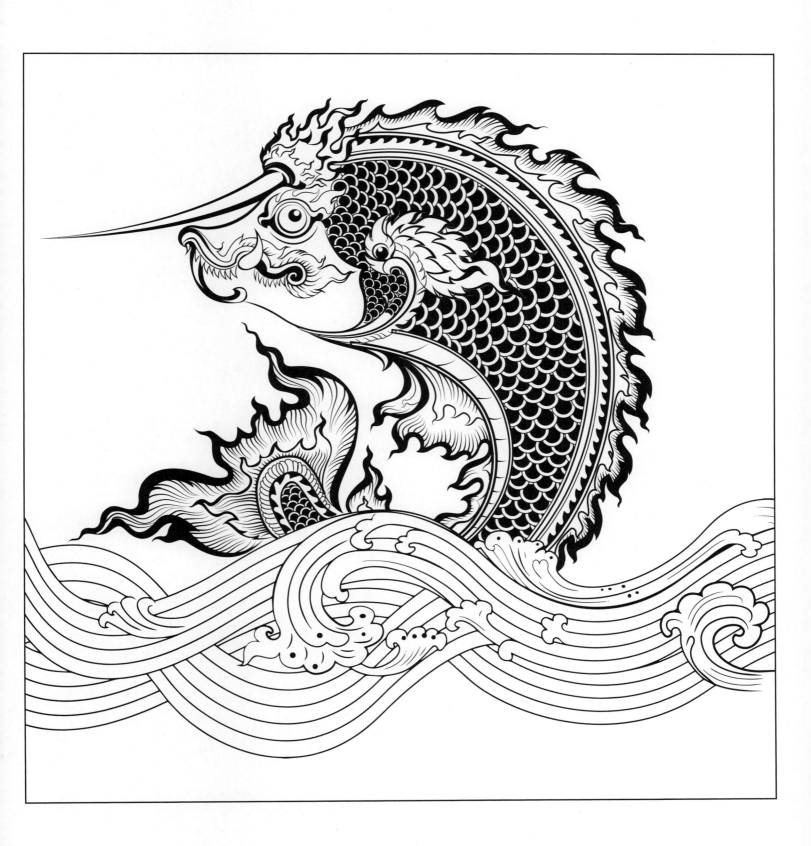

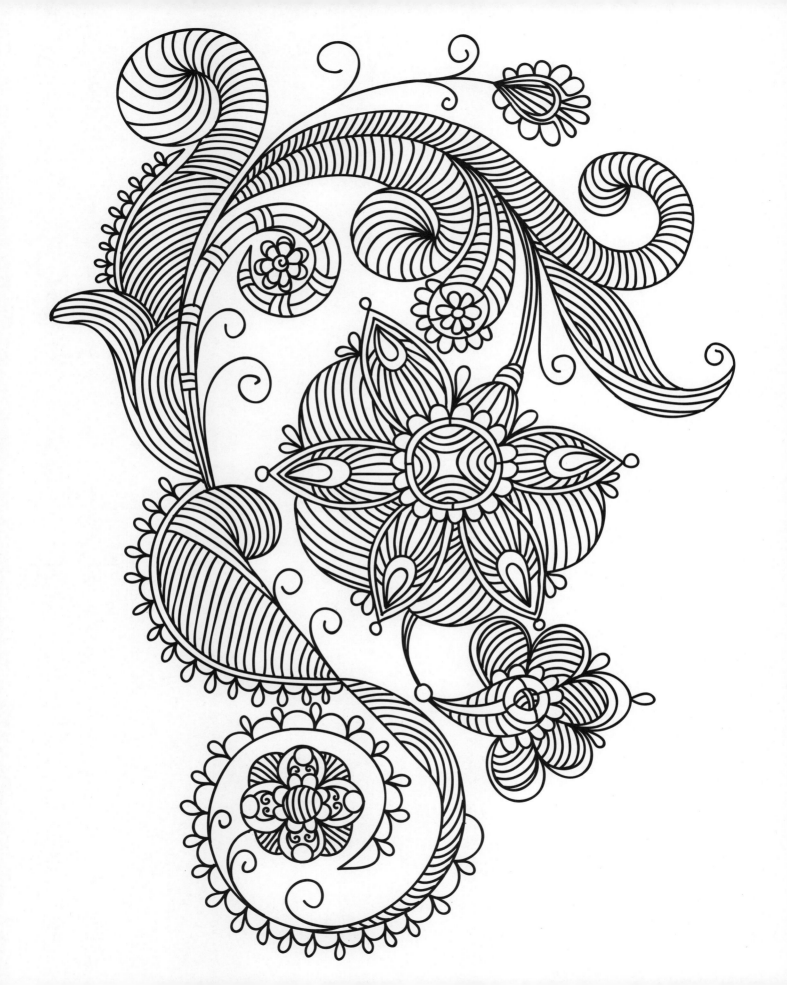

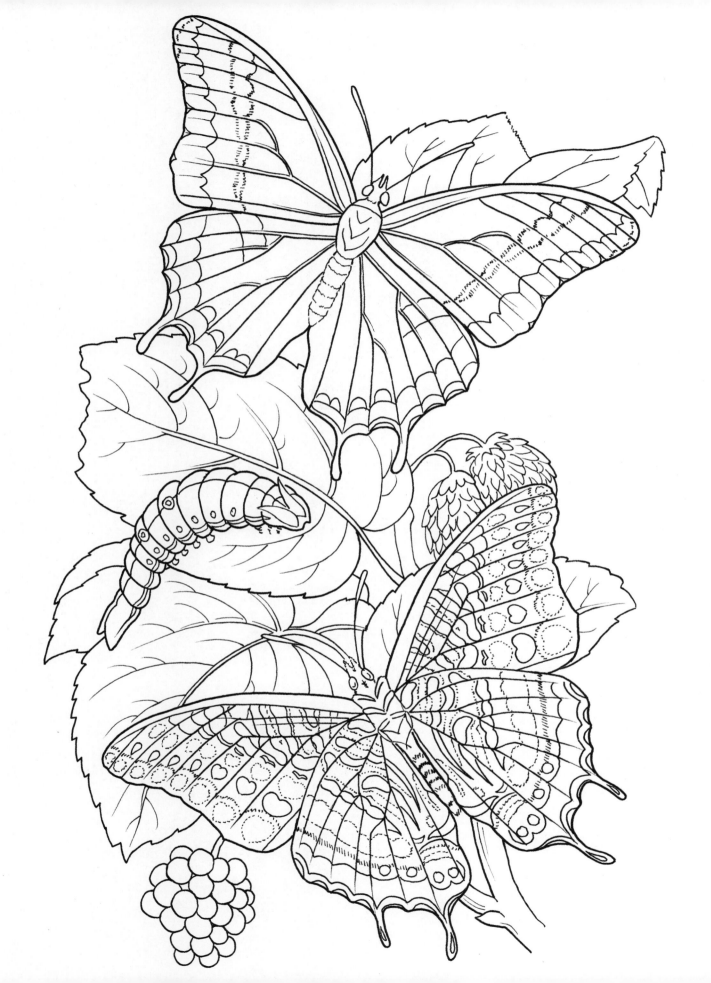

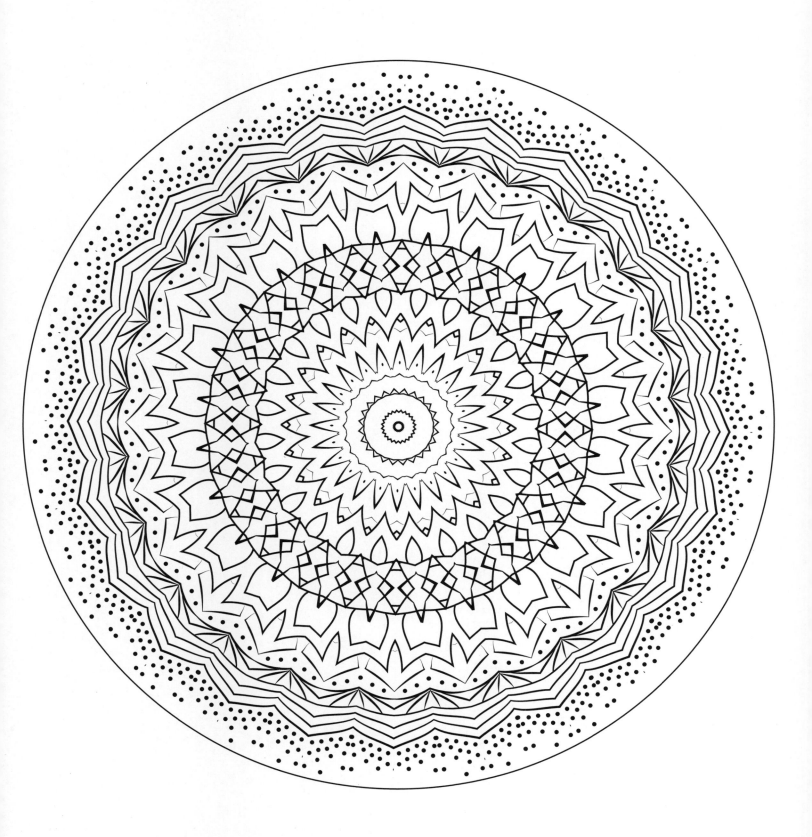

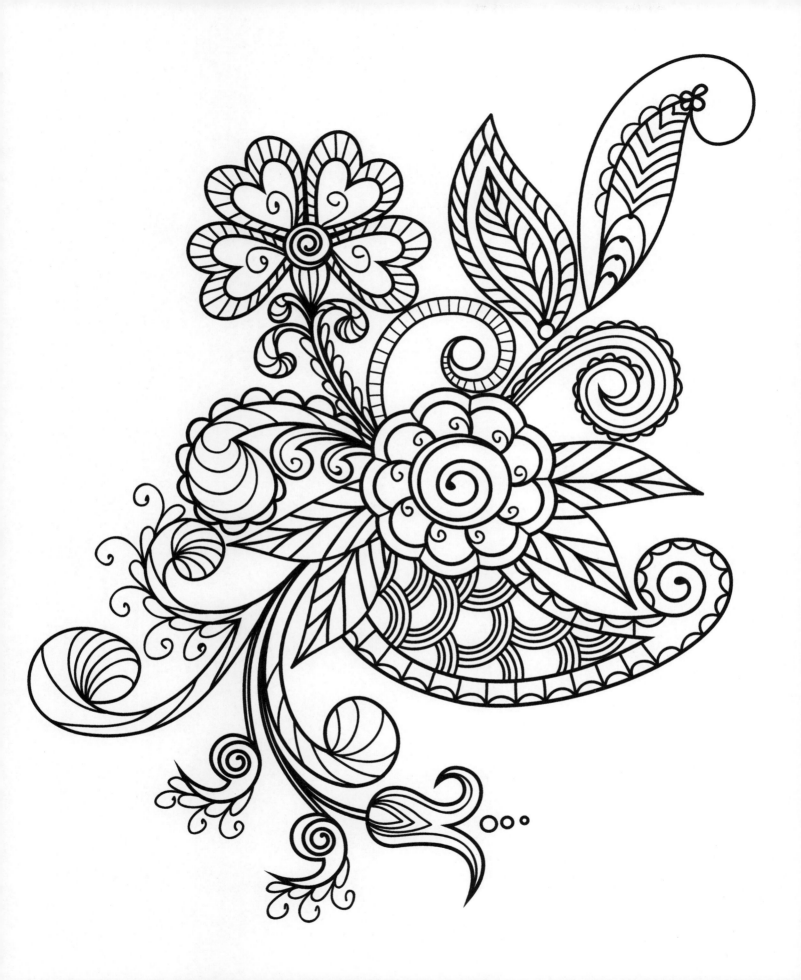

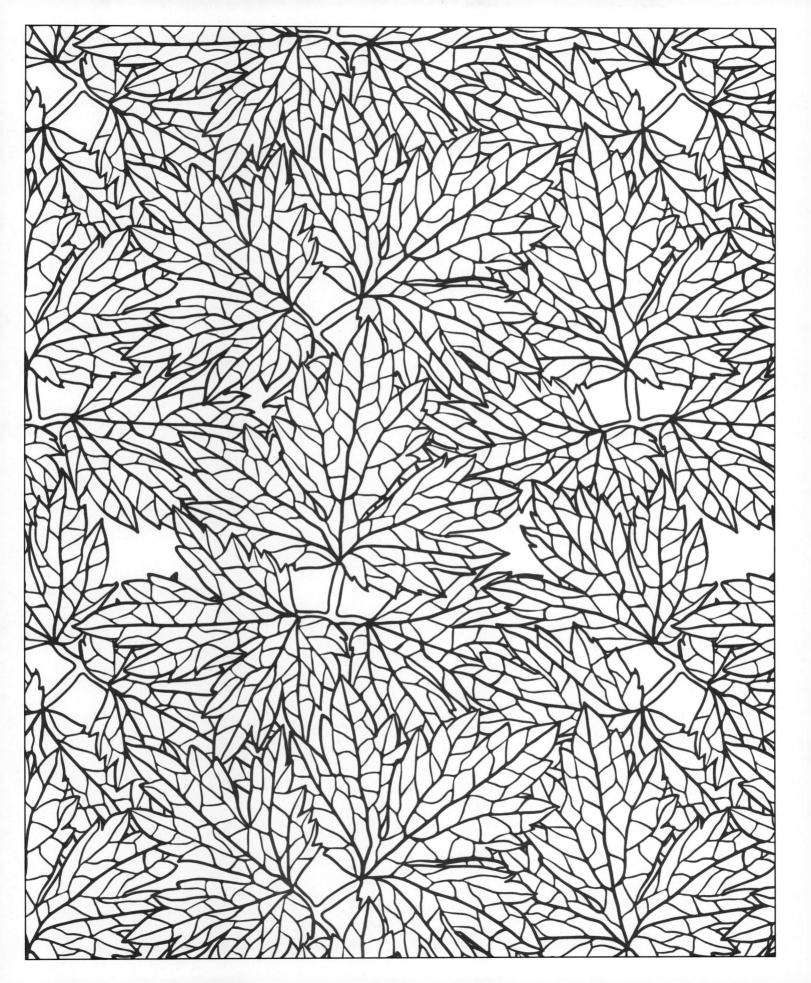

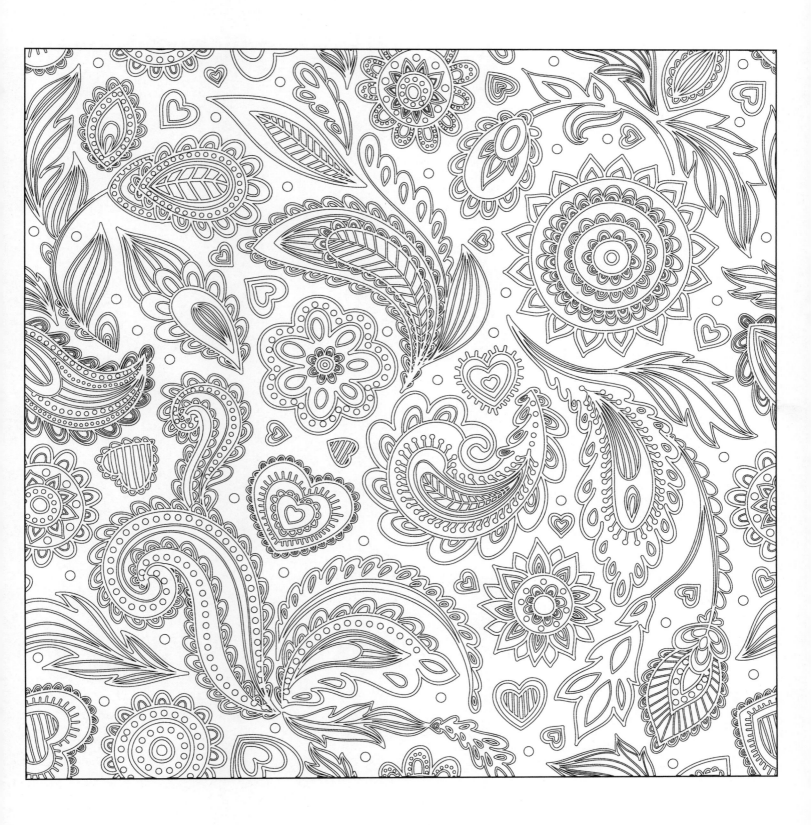

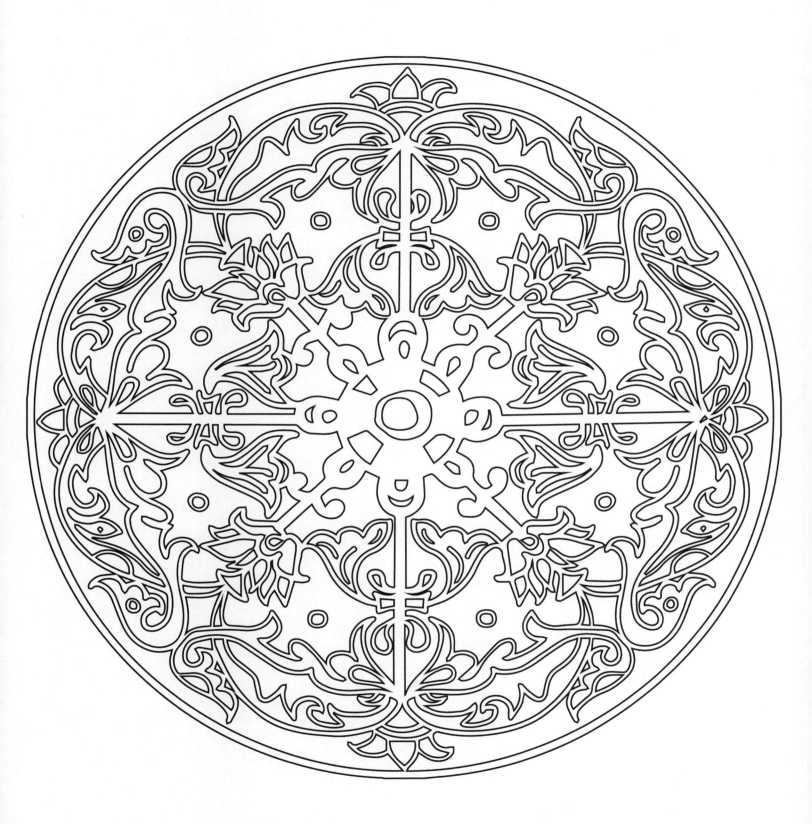

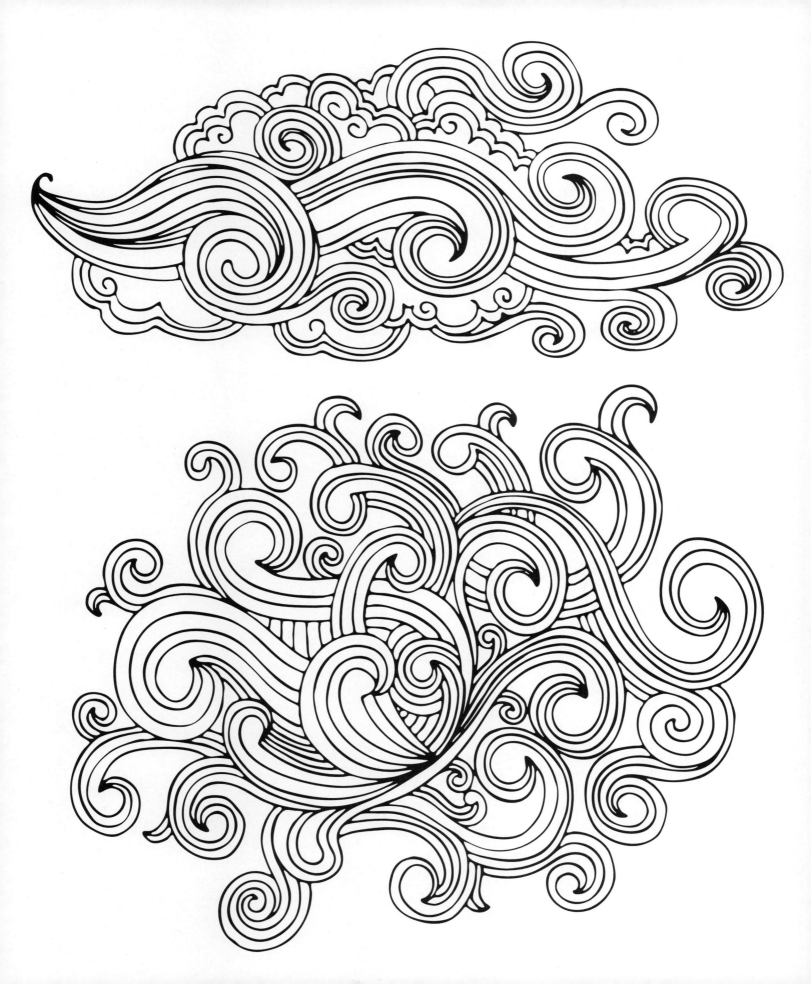

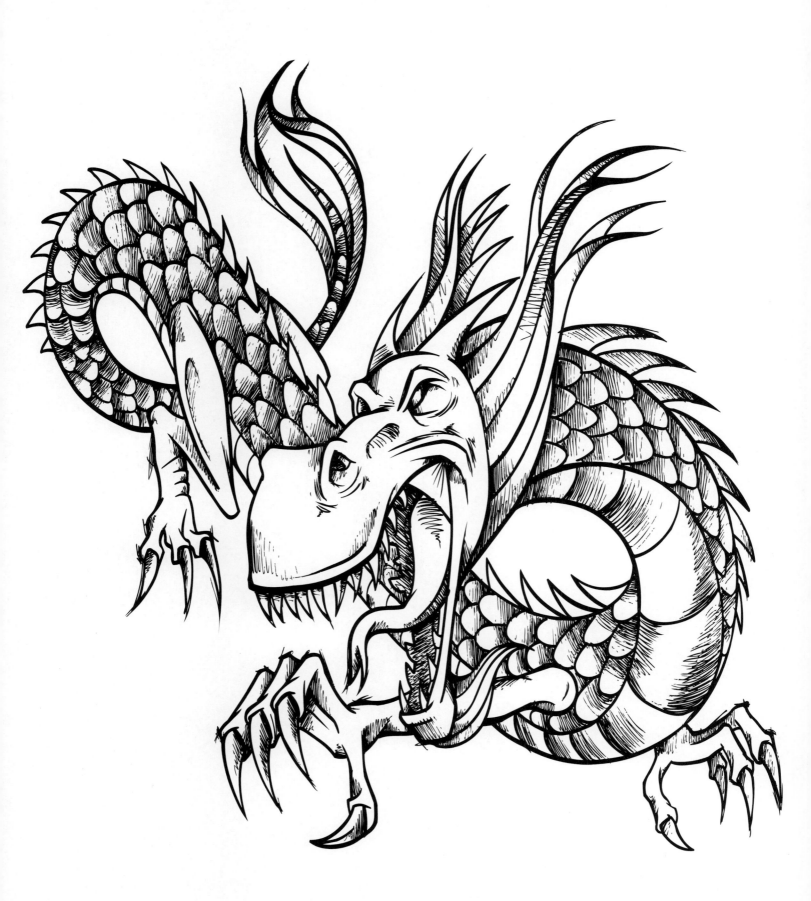

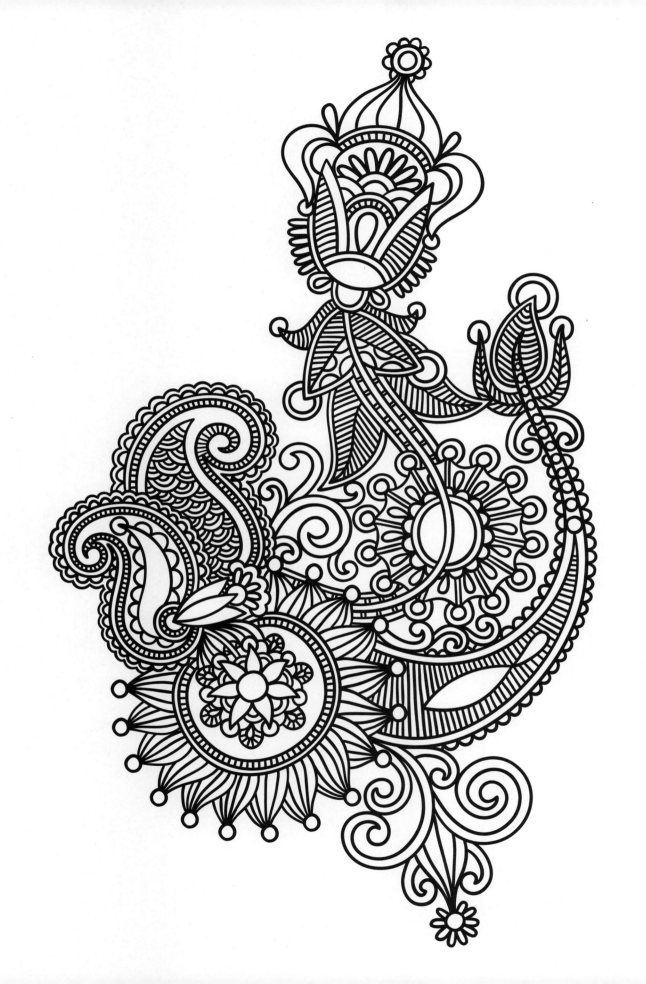

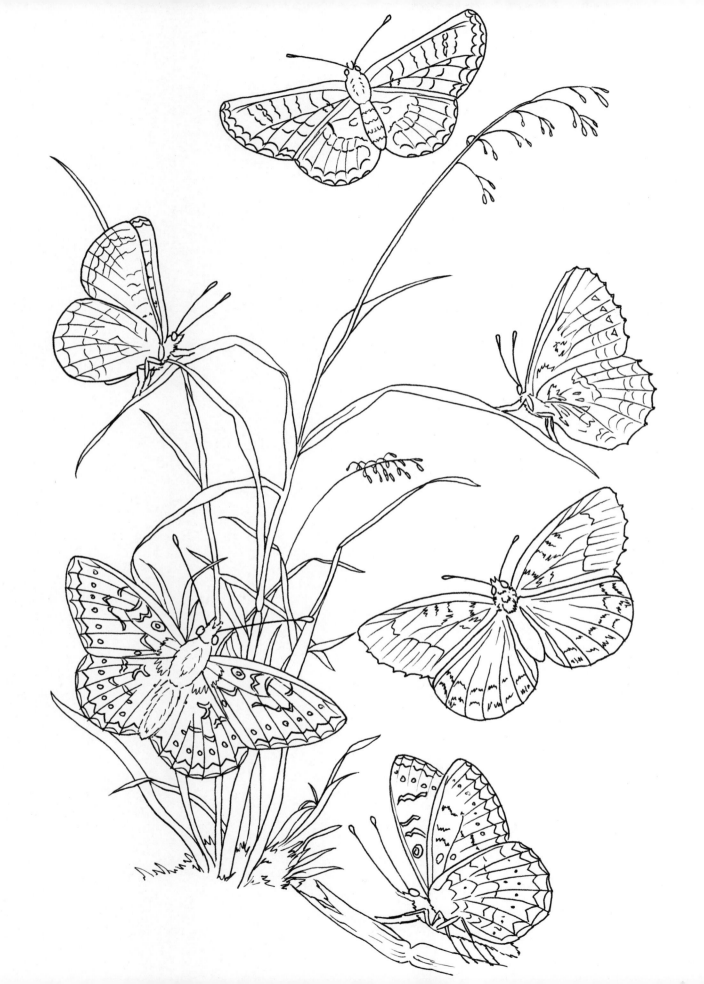

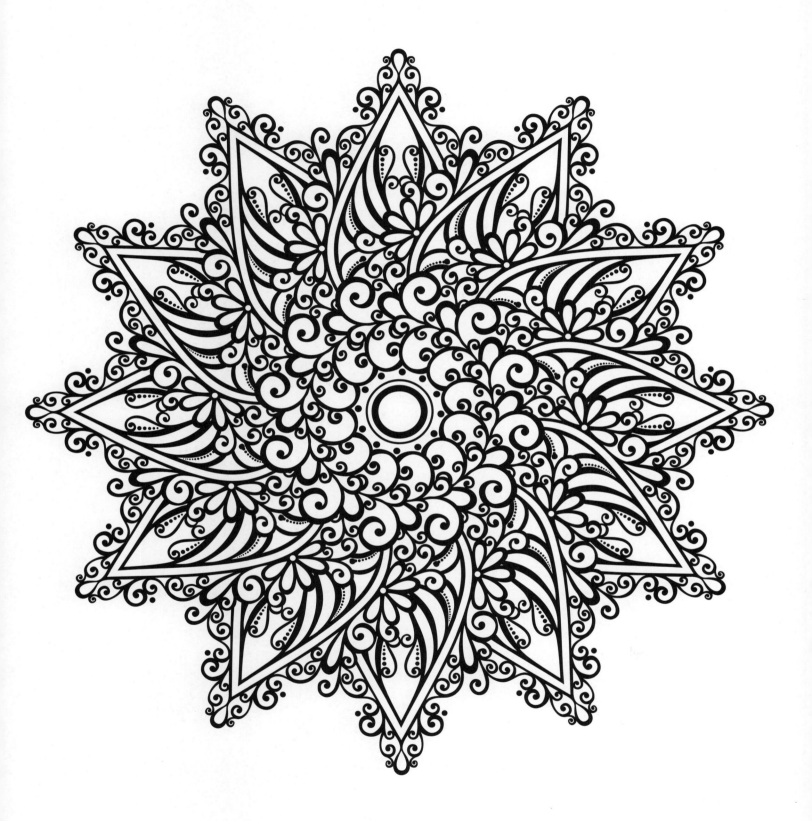

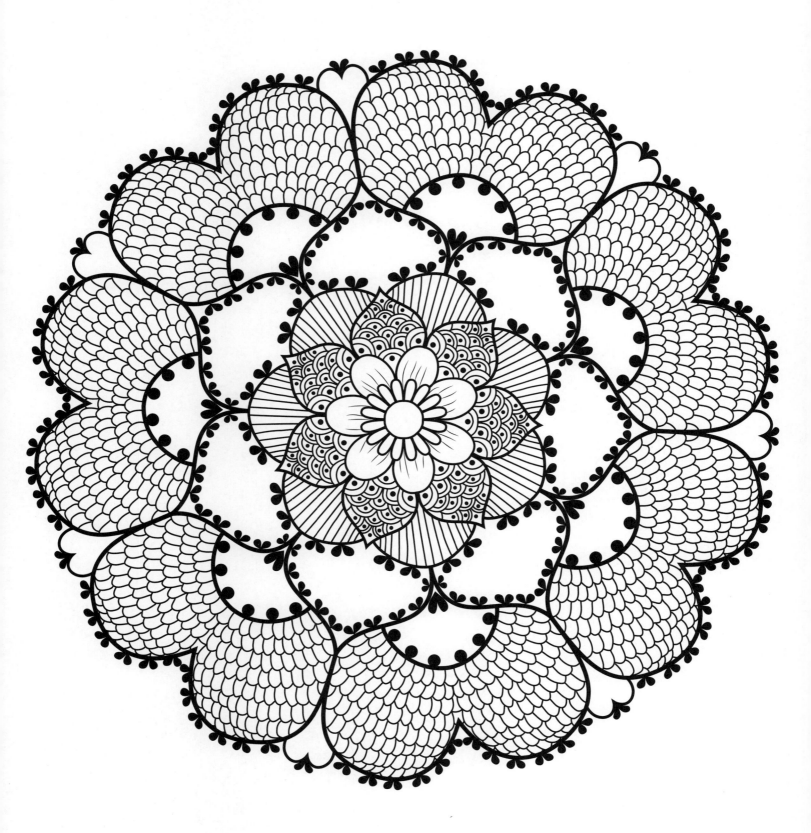

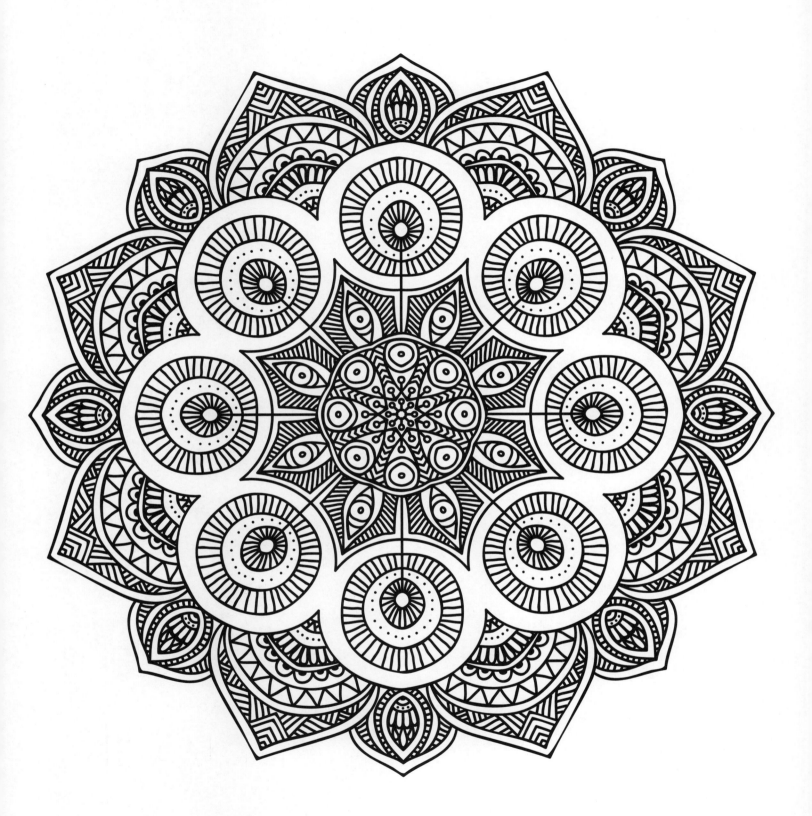

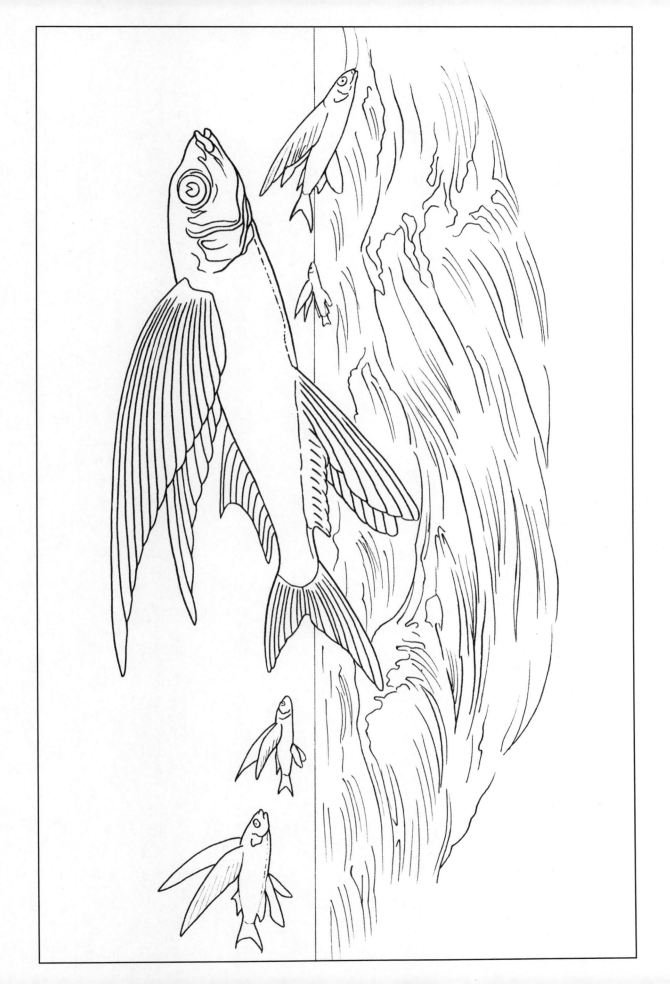

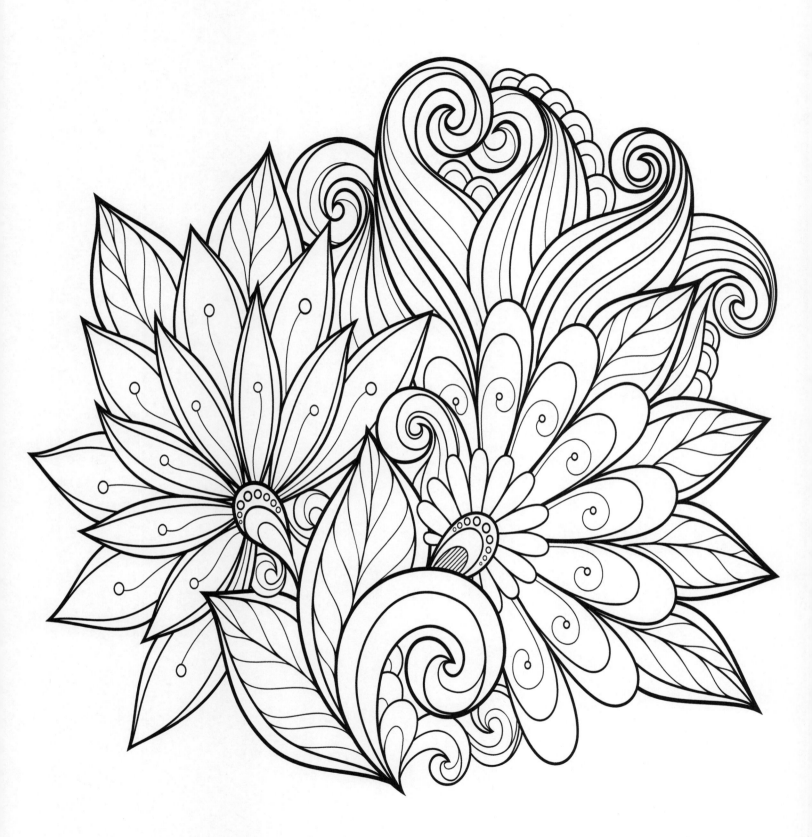

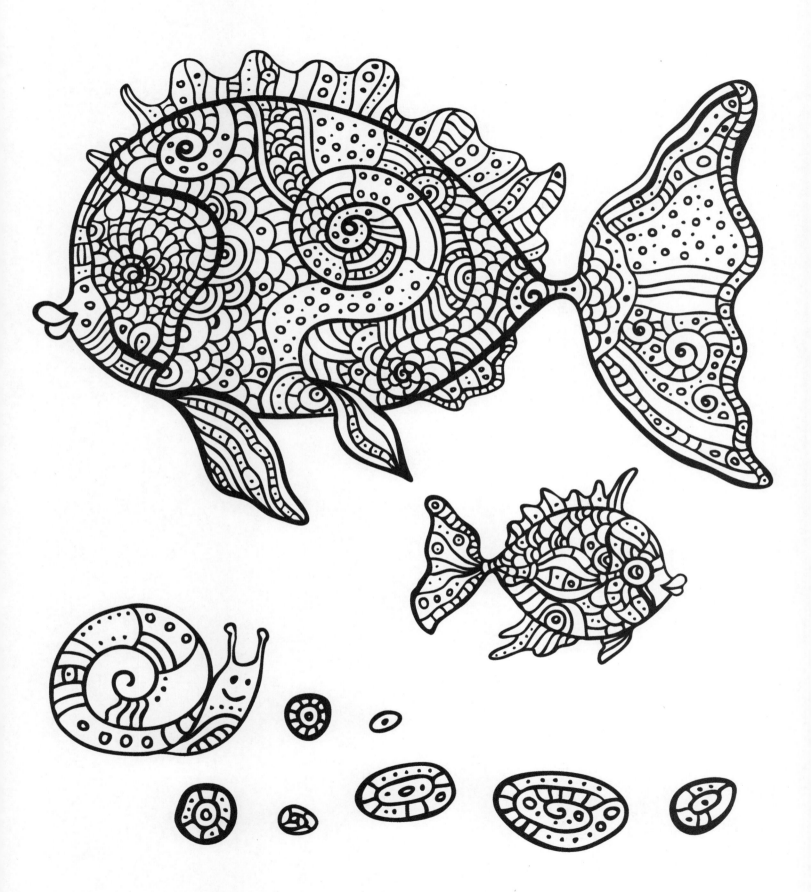

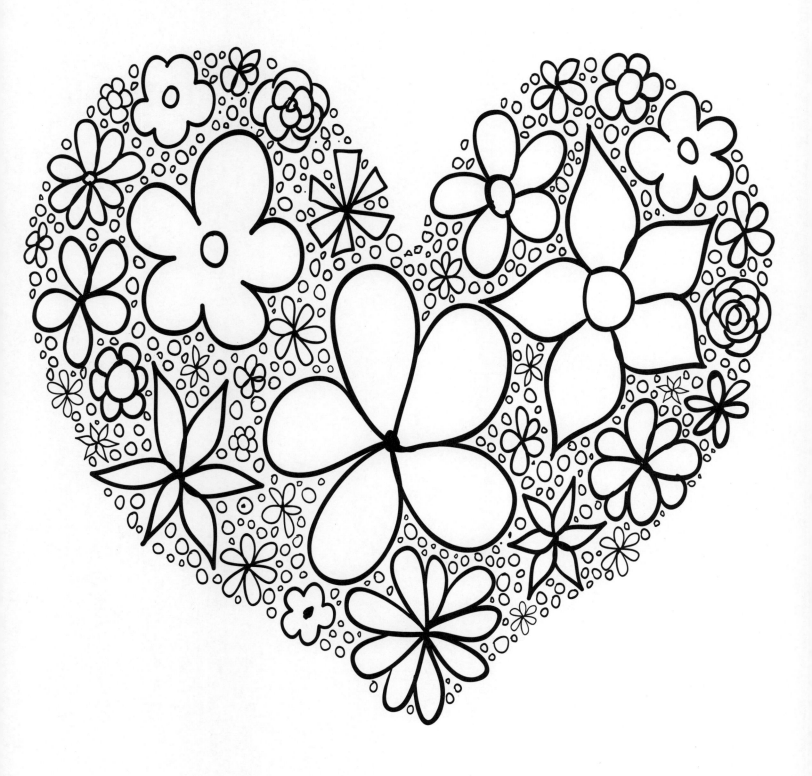

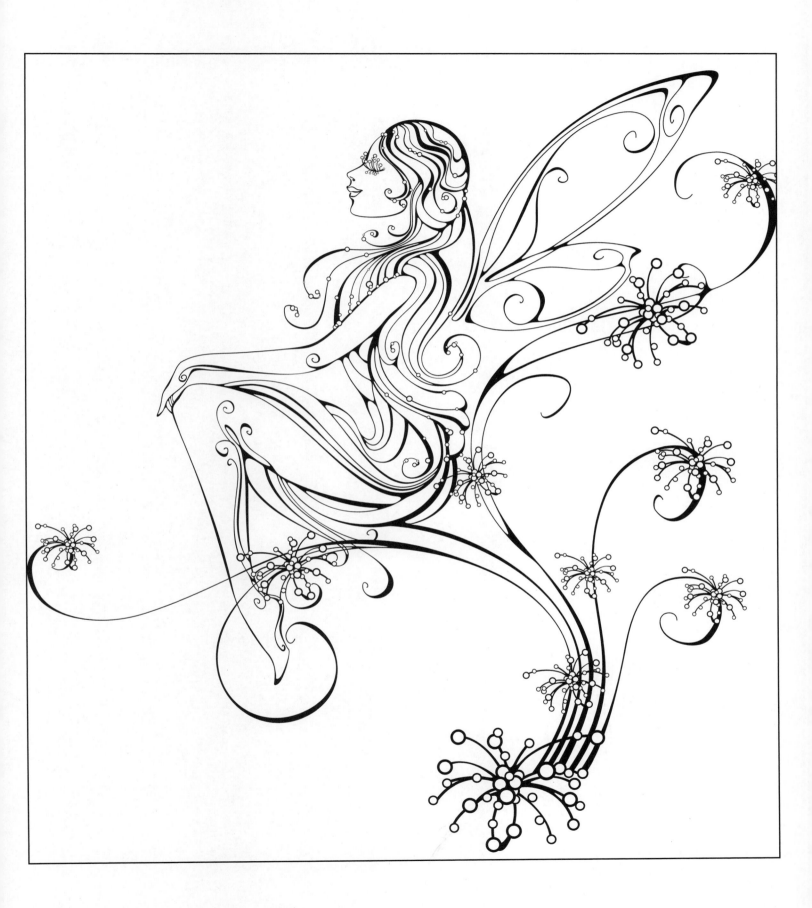

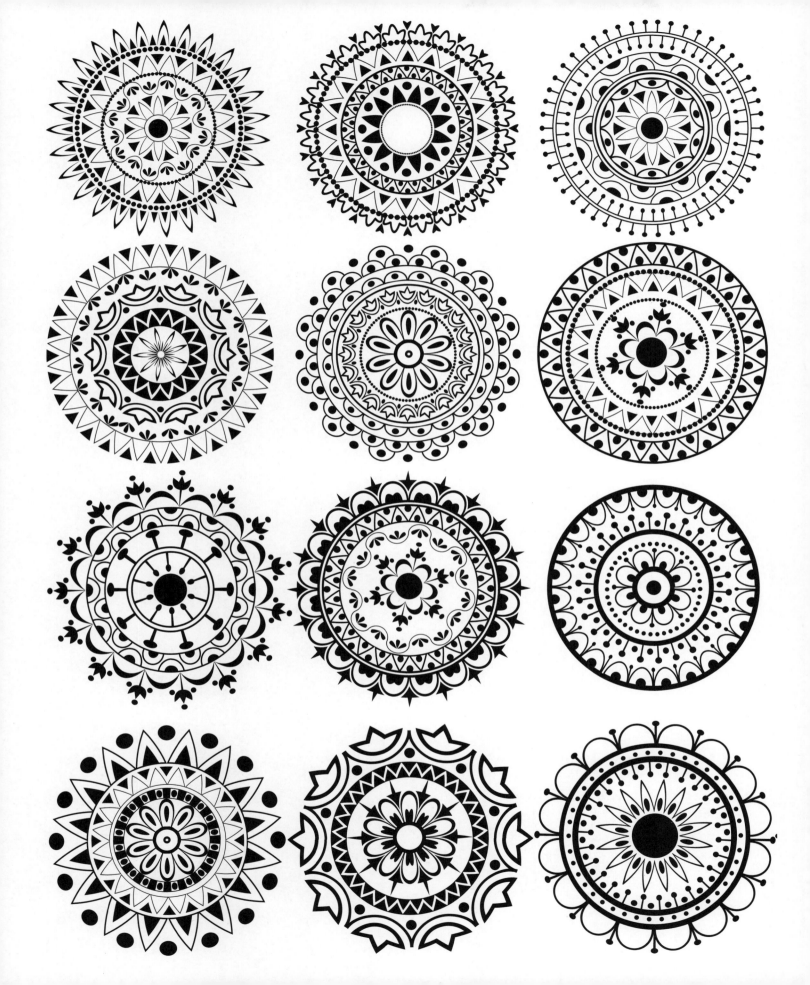

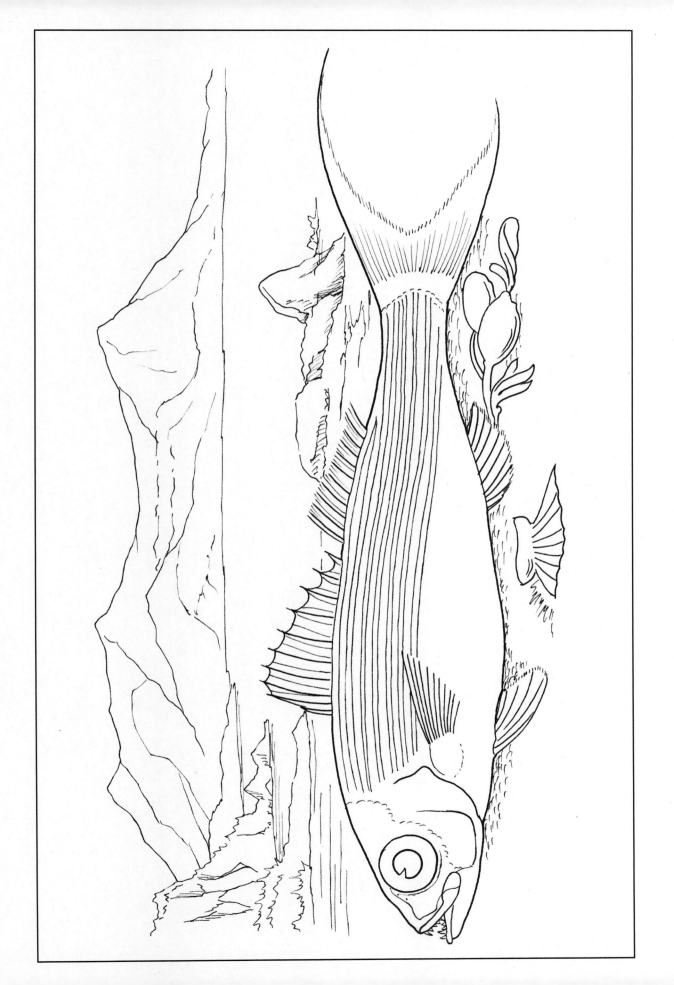

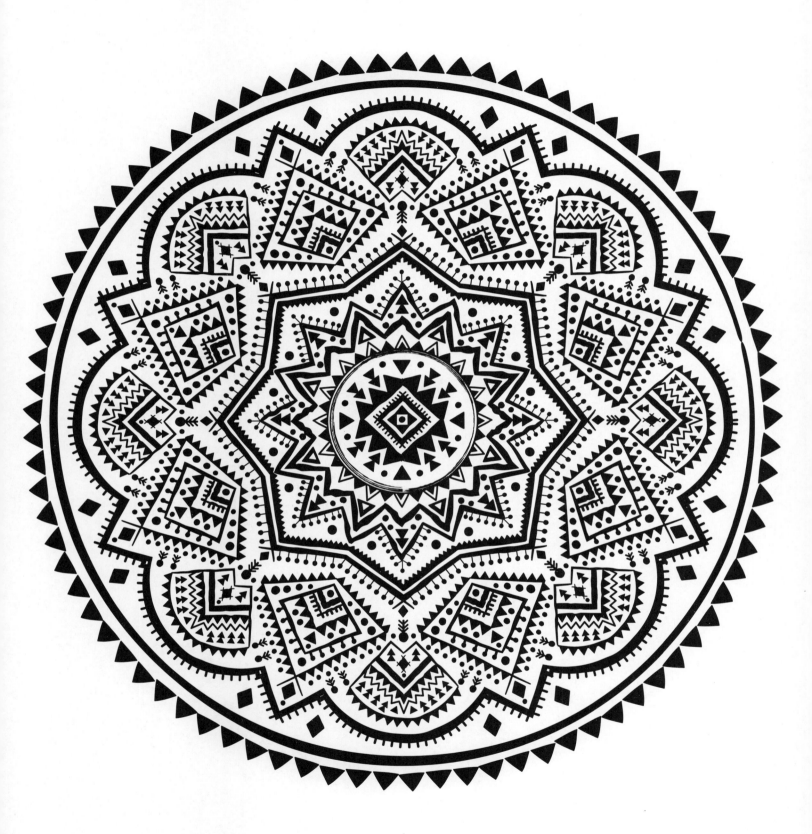

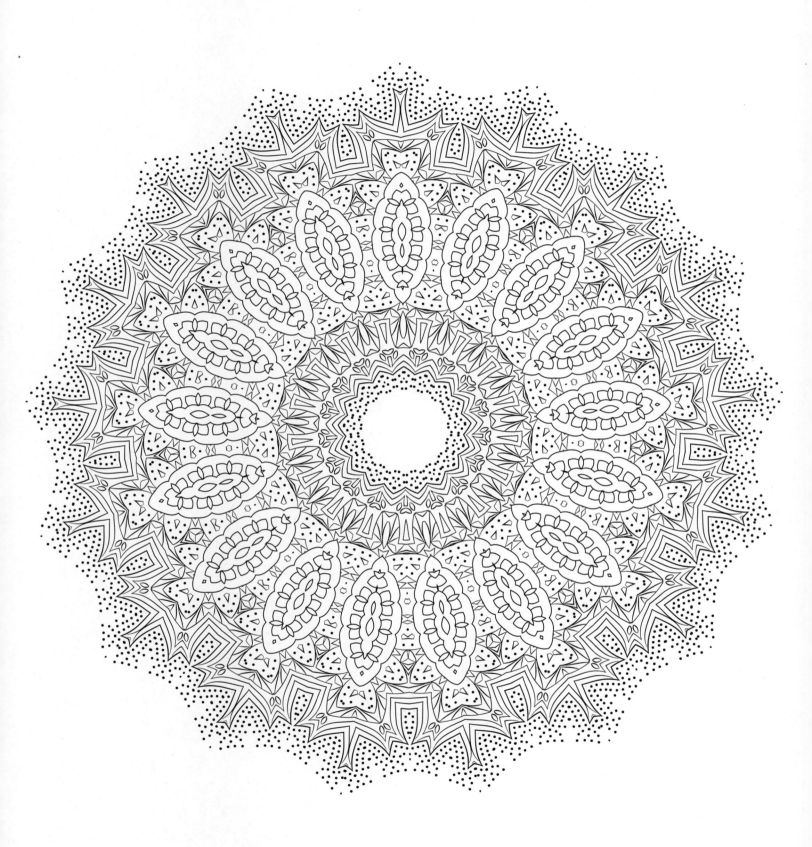

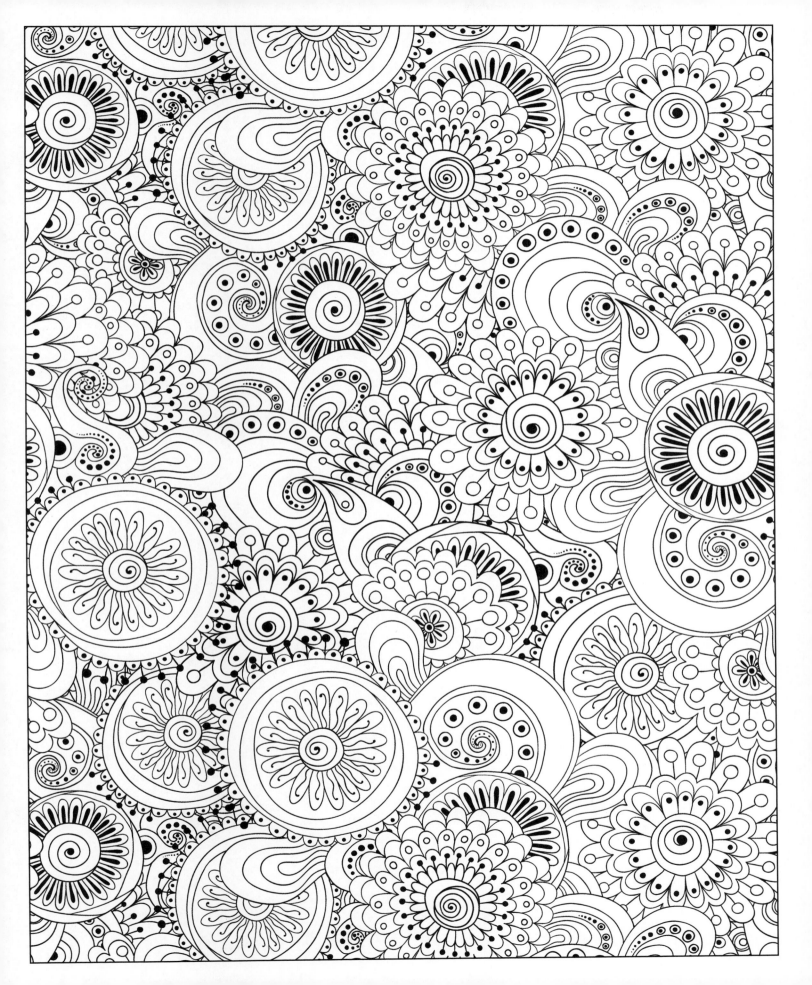

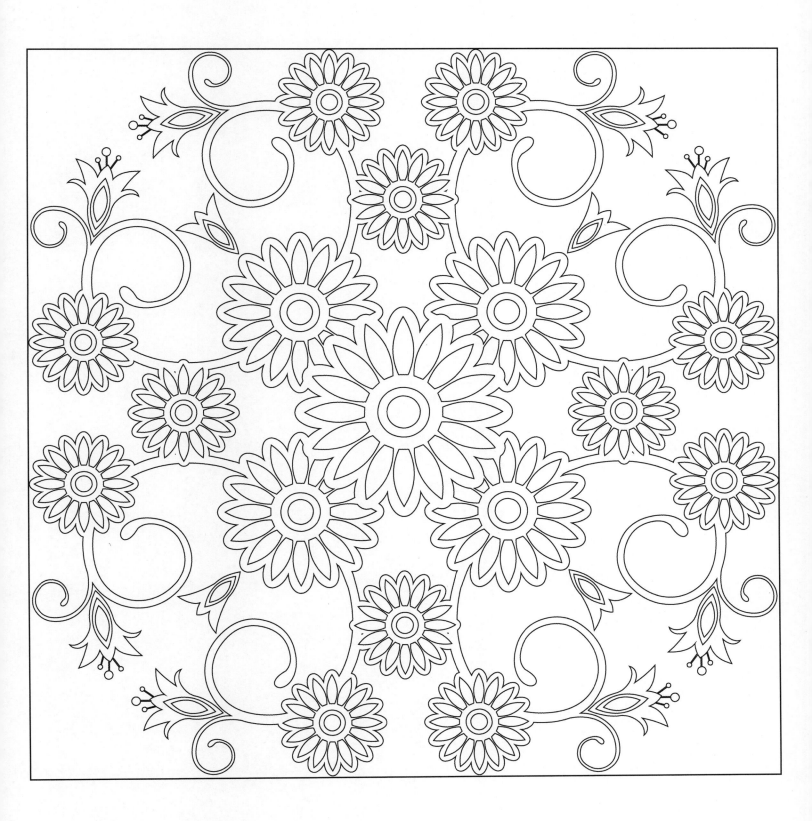

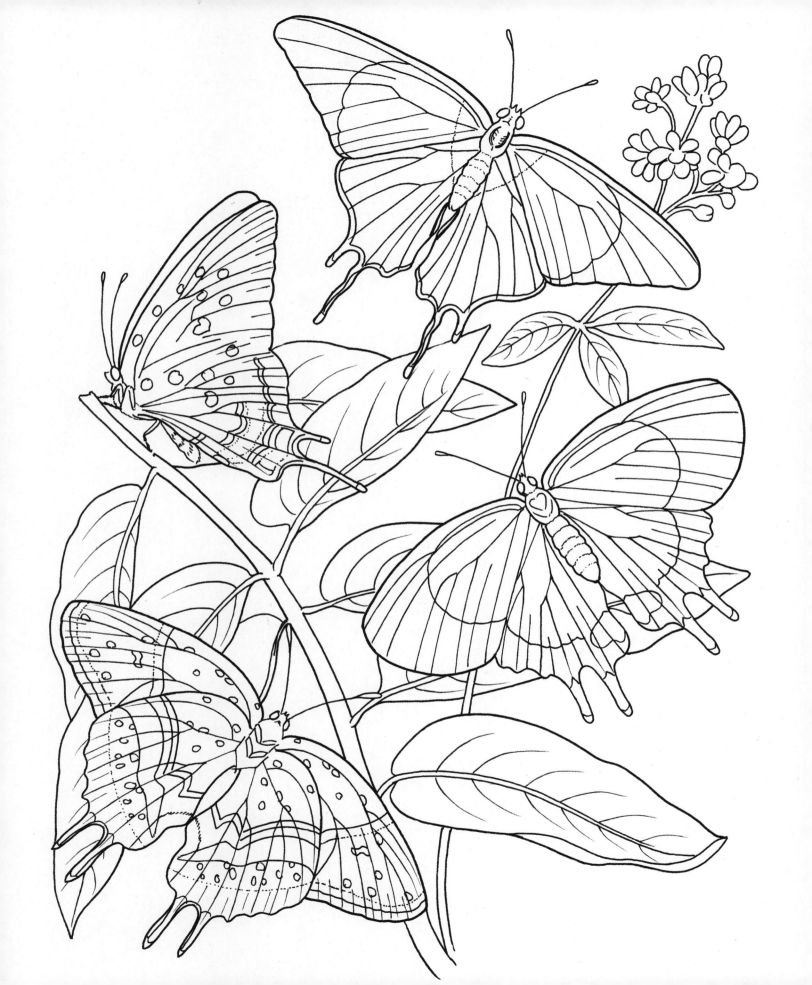

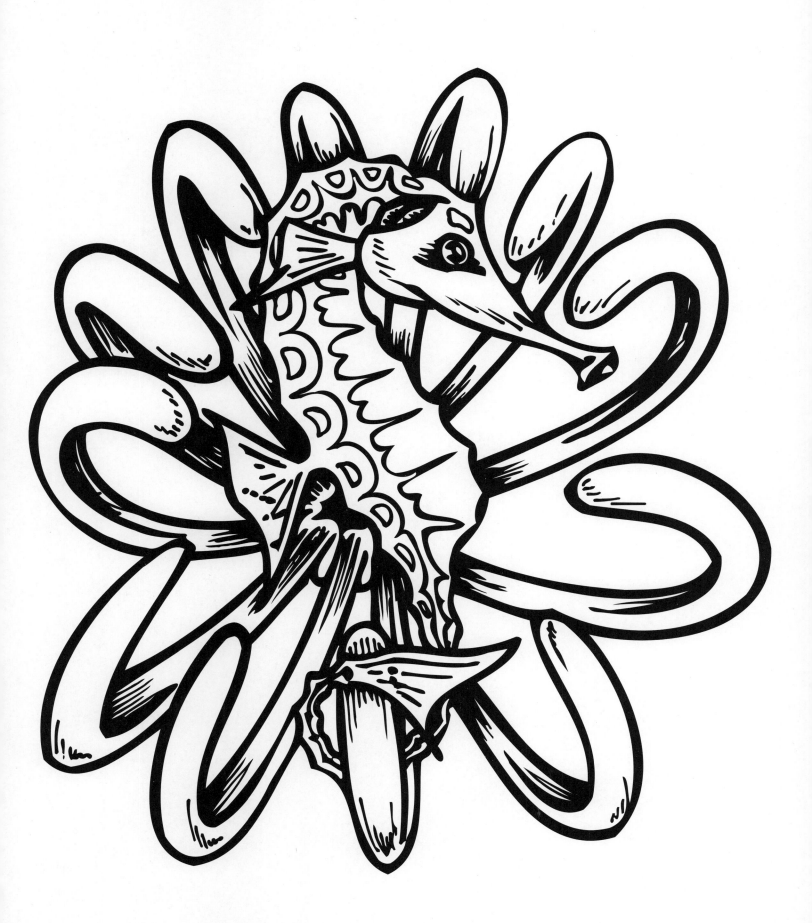

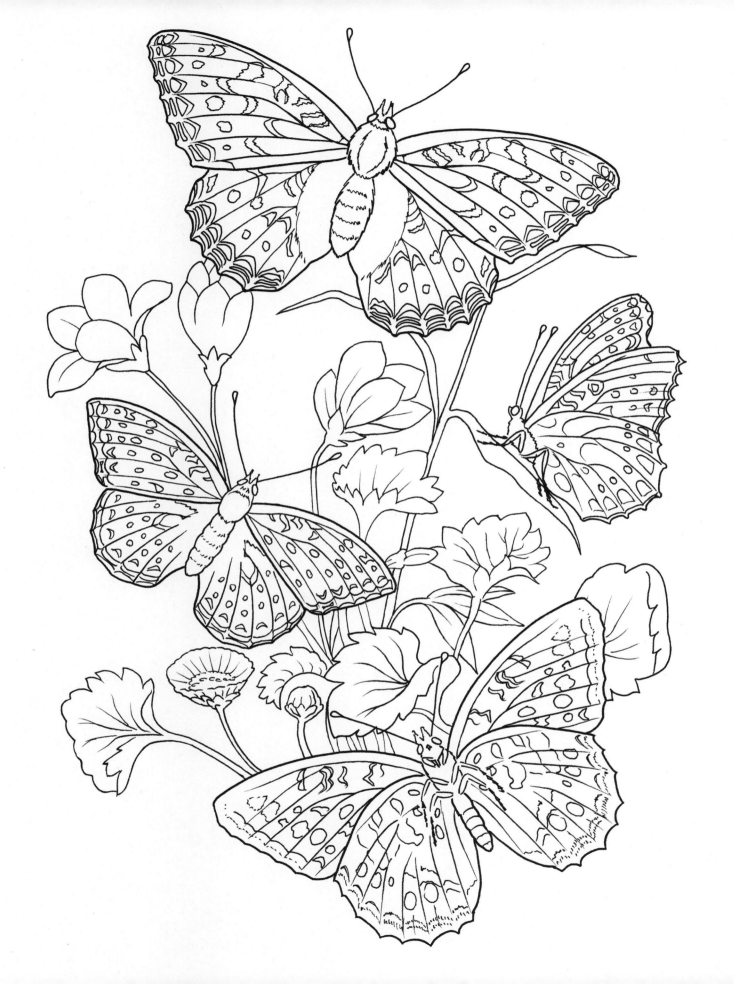

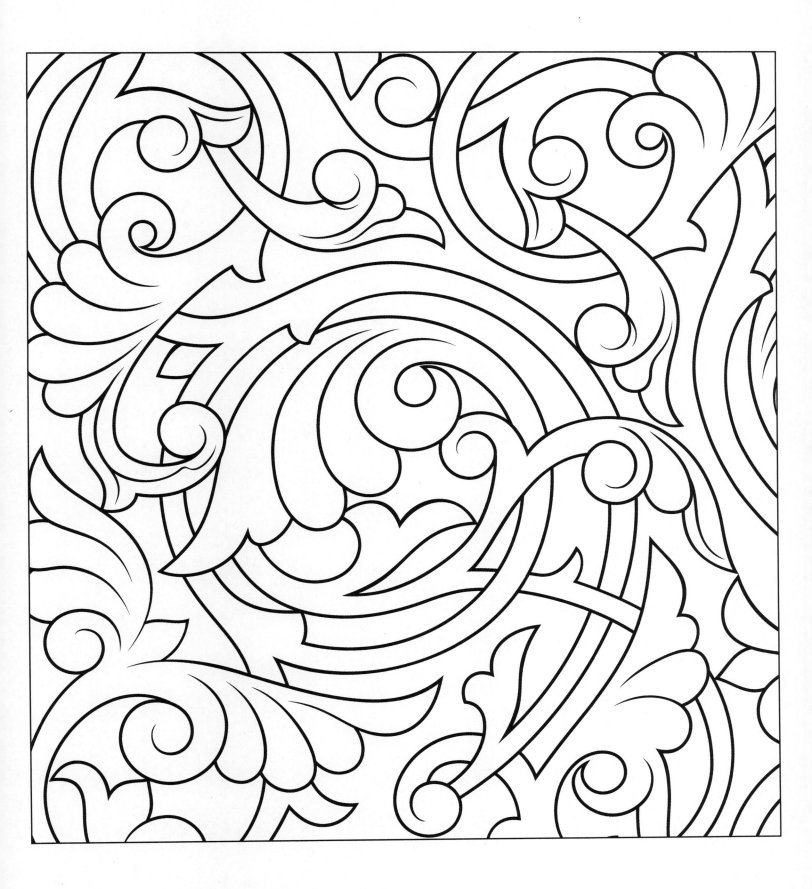

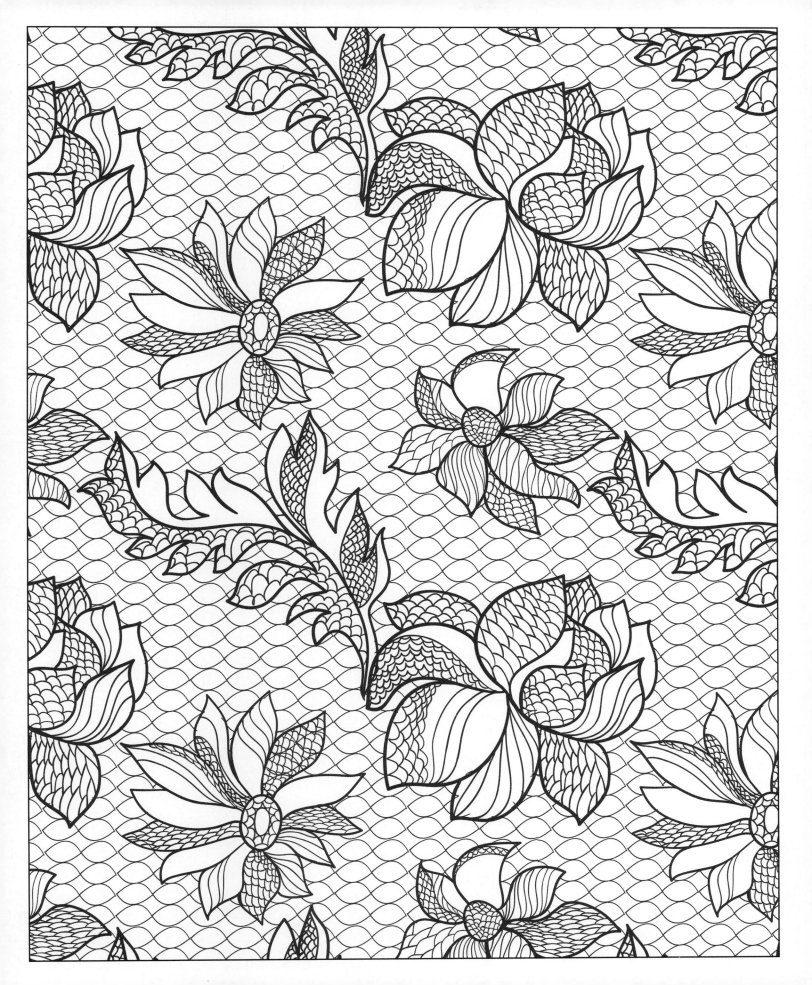

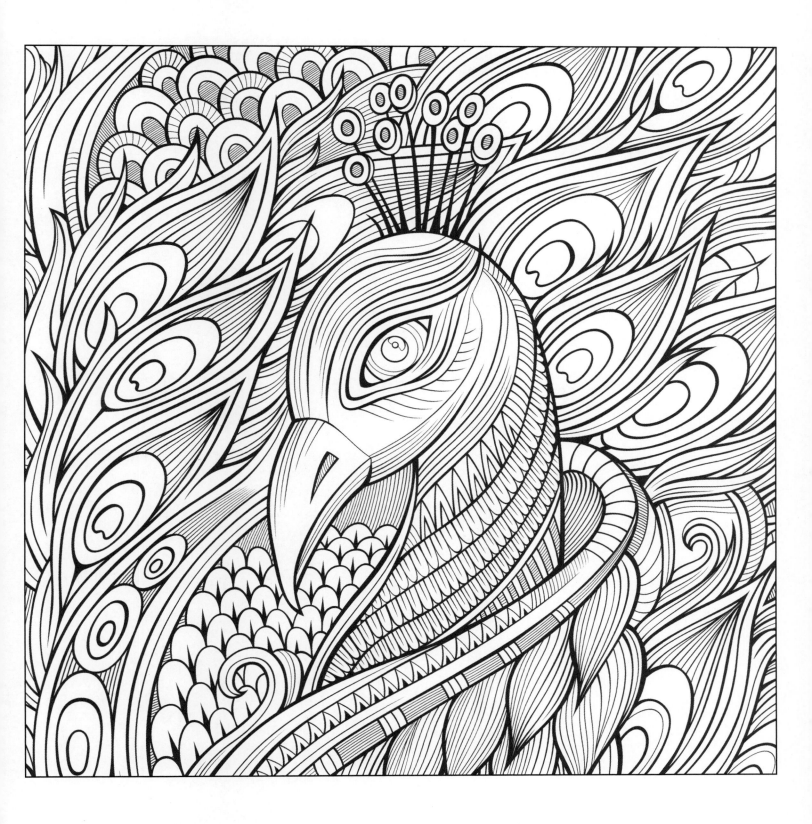

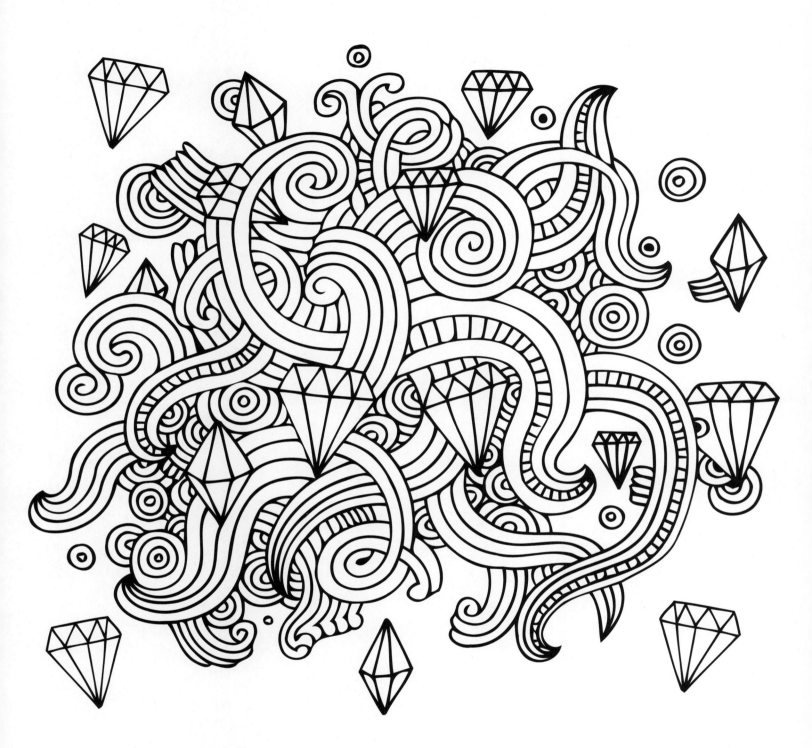

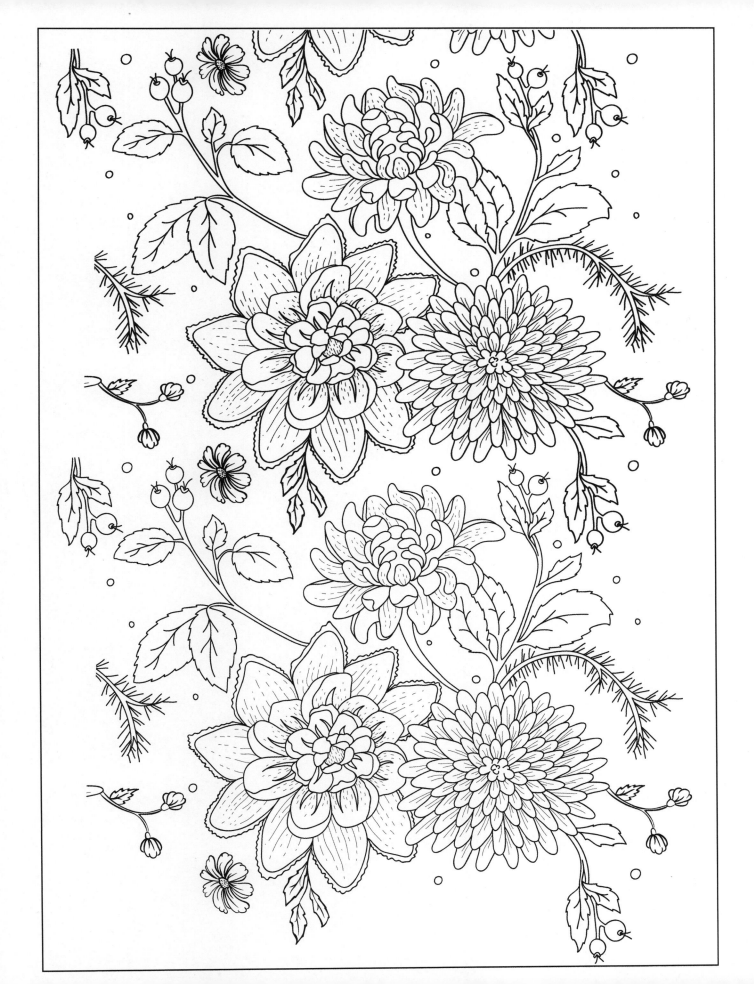

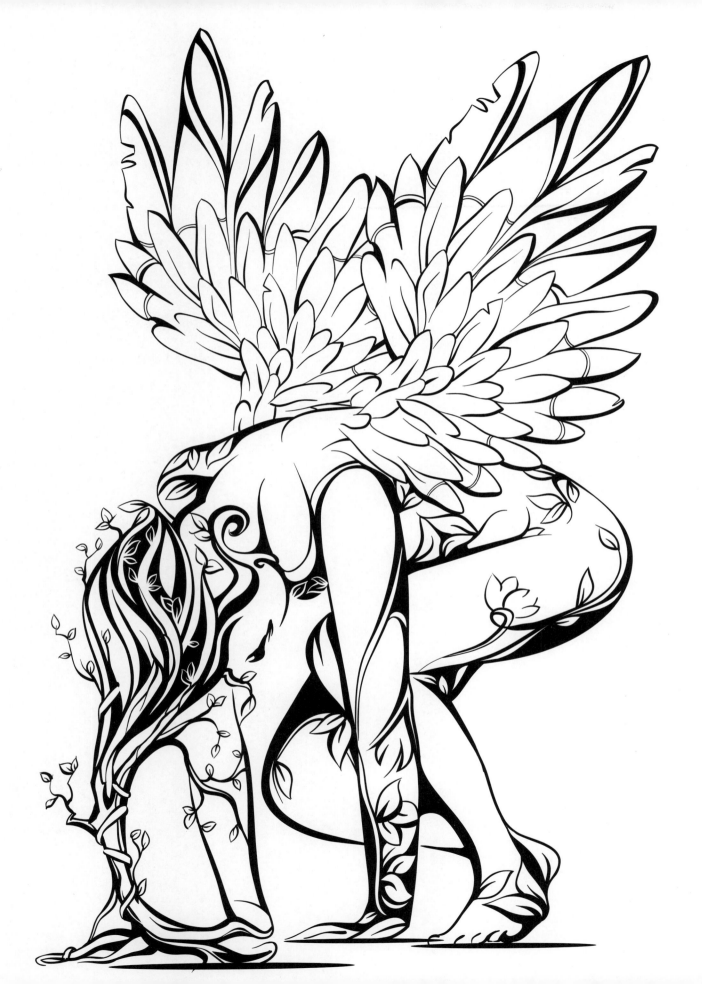

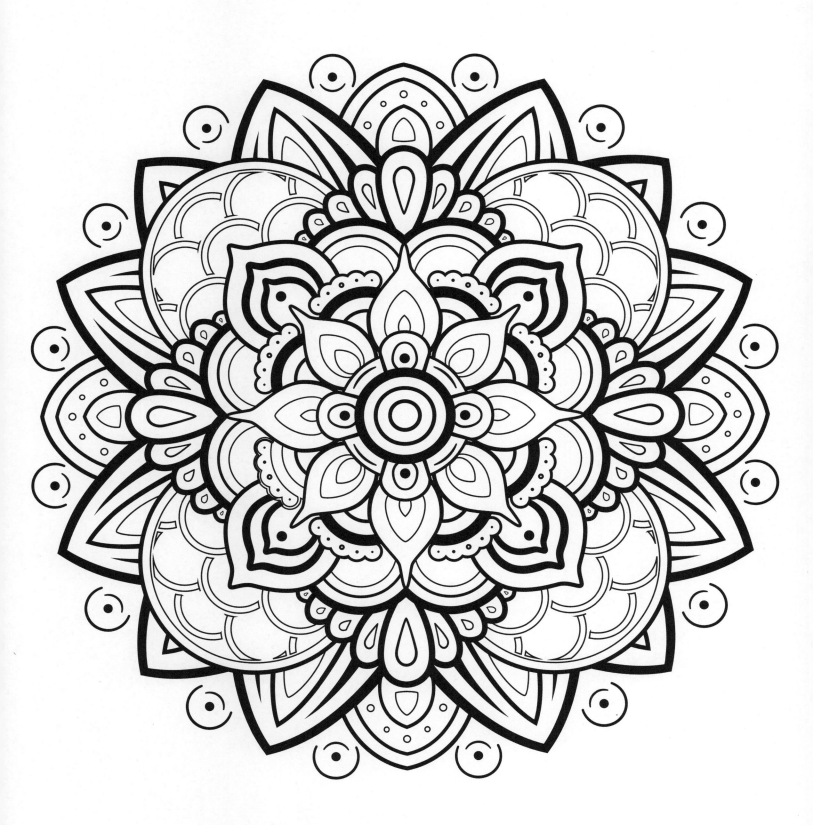

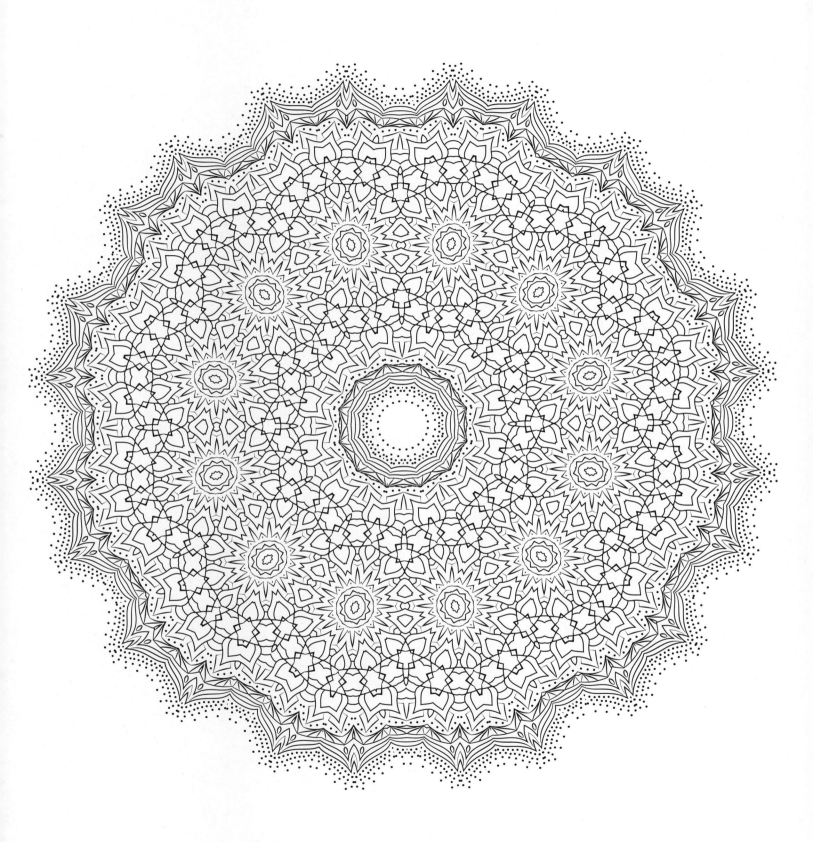